IMAGES
of America

MELROSE PARK

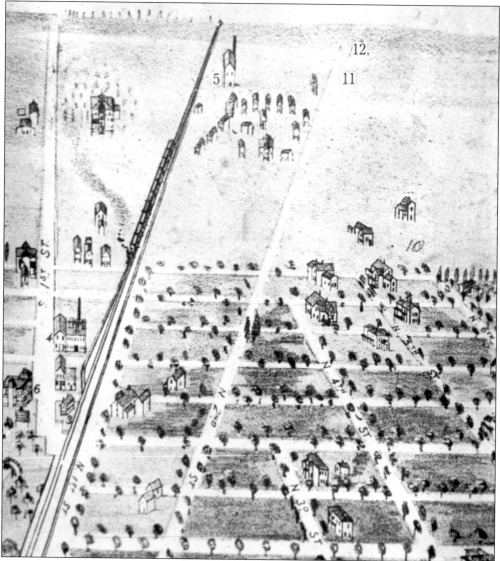

Drawn by August Koch in 1873, this lithograph depicts the streets and buildings that were eventually incorporated into the town of Melrose Park in 1882. Like many of the surrounding communities, the town grew around the railroad tracks running across the prairie. (Courtesy of the Melrose Park Historical Society.)

IMAGES
of America

MELROSE PARK

Fidencio Marbella and Margaret Flanagan

ARCADIA
PUBLISHING

Published by Arcadia Publishing
Charleston SC, Chicago IL, Portsmouth NH, San Francisco CA

Printed in the United States of America

Library of Congress Catalog Control Number: 2008942742

For all general information contact Arcadia Publishing at:
Telephone 843-853-2070
Fax 843-853-0044
E-mail sales@arcadiapublishing.com
For customer service and orders:
Toll-Free 1-888-313-2665

Visit us on the Internet at www.arcadiapublishing.com

To the residents of Melrose Park, past, present, and future.

CONTENTS

ACKNOWLEDGMENTS

Unless otherwise noted, the photographs in this book are from the collection of the Melrose Park Historical Society. Melrose Park Public Library staff members have been organizing and archiving this photographic collection for the past two years.

This book would not have been possible without the generous contributions of many people. Special thanks goes to the reference staff of the Melrose Park Public Library, especially to our archival expert Heidi Beazley, who organized and digitized most of the photographs, and to our computer guru Julia Gregory, who provided both time and invaluable technical expertise.

Longtime Melrose Park residents Josephine Prignano, John Misasi, and library director Barbara Giordano contributed their treasured photographs, memories, and knowledge of our town.

Most of the contemporary photographs featured in chapter 7 were taken by Fenwick High School photography club members Araceli Diaz, Bridget Kern, Joellyn Schefke, Christopher Wojewoda, and teacher Ron Stuart.

Other significant information and assistance was provided by George Bellini, Chuck Cusumano, Peggy DiFazio, Lucia Esposito, Mary Esposito, Rebecca Hunter, Mark Johnson, Cindy Maiello-Gluecklich, Peter Marella, Anthony Prignano, Corrine Principe, Todd Quesada, Eamon Rago, Diane Ravenesi, Ralph Ravenesi, Ralph Tolomei, and Carol Zimmer.

INTRODUCTION

Originally populated by German immigrants, Melrose Park was incorporated on September 11, 1882. Developed by the Melrose Realty Company and its owners, Allen Eaton and Edward Cuyler, the village was initially known as Melrose until citizens voted to change the name to Melrose Park in March 1893.

Due to its close proximity to Chicago and its position on the Chicago and Northwestern Railway, Melrose Park soon became a center for manufacturing and heavy industry. This prairie region was rapidly transformed into a bustling community with the influx of immigrants seeking well-paying industrial jobs and affordable housing.

The original German settlers were soon joined by an influx of Lithuanian immigrants. After about 1900, a major wave of Italians immigrated to Chicago. One of the significant enclaves established by these new arrivals was in Melrose Park. For over 60 years, this strong Italian presence virtually defined the culture of the area. Beginning in the 1980s, an influx of Latino immigrants once again began changing the face of Melrose Park.

Although the suburb of Melrose Park grew by leaps and bounds through the first half of the 20th century, it still retained many of its rural traditions. The town, famous for its Melrose peppers initially brought to the area by Italian immigrants, included large tracts of fertile farmland. Naples Farmstand in Melrose Park was famous throughout the Chicagoland area for its fresh produce. Many Melrose Parkers grew their own squash, zucchini, lettuce, and tomatoes and kept small farm animals on their property. Longtime resident John Misasi remembers raising chickens, pigeons, and even a goat within the confines of his backyard.

Farming and industry coexisted in Melrose Park for decades. Companies of note included Richardson's Manufacturing, the Rowland Picture Tube Division of Zenith Television, International Harvester, National Malleable and Steel Castings Company, and the Alberto-Culver Company. These companies and many others provided countless jobs for Chicago area residents and gave rise to the Melrose Park town slogan, Corporate King of the Suburbs.

As manufacturing grew in the post–World War II era so did the demand for more housing. The building of the Winston Park subdivision and the Winston Park Plaza shopping center in the late 1950s signaled the beginning of the end of the rural character of Melrose Park. As acres of vacant land were sold and converted into businesses and residential neighborhoods, the town evolved into a modern suburb.

Although the landscape of the village has changed radically, many of its most cherished cultural traditions still remain. Among them, the Feast of Our Lady of Mount Carmel (Festa della Madonna), a traditional 10-day Italian celebration featuring a novena, a religious processional,

and a carnival honoring Our Lady of Mount Carmel is held every July, drawing a host of visitors and celebrants to Melrose Park. More recently, the Taste of Melrose Park, featuring a wide sampling of ethnic foods reflecting both old and new Melrose Park, has become an annual September tradition. The strong Latino presence in the village is reflected through HispanoFest, a celebration of Latino culture that includes music, food, and dance.

In many ways, the history of Melrose Park mirrors the history of other midwestern prairie communities that were transformed by the development of railroads, the heavy industry that followed, and the influx of different immigrant groups seeking the American dream. This pictorial history provides an overview of a vibrant, ever-adapting community that actively embraces its old traditions while creating new ones.

One

EARLY DAYS

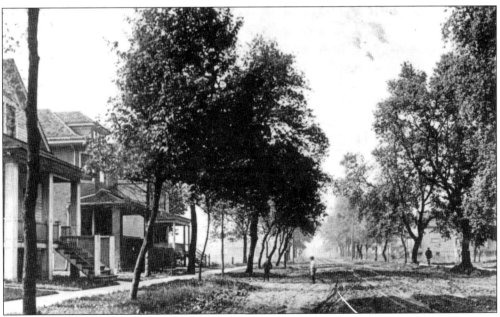

Around 1895, this street scene depicts Eleventh Avenue looking north from Lake Street. Houses, sidewalks, and relatively mature trees are already present, yet the streets still remain unpaved. In the early days of the village, before the advent of automobile traffic, the unpaved streets often served as informal playgrounds and meeting places for neighborhood children.

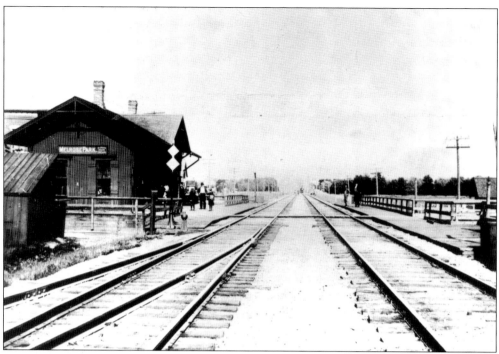

The Galena and Chicago Union Railroad (and later the Chicago and Northwestern Railway) played a significant role in the development of early Melrose Park. Note the train in the distance running along the left-hand track rather than the right; this unique Chicago and Northwestern Railway tradition continues up through this day.

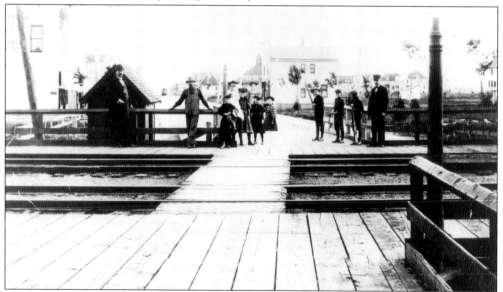

Only towns along the all-important rail lines were destined to thrive. Local residents relied on the railroads for all their transportation and shipping needs. In this 1892 photograph, residents gather at the pedestrian crossing at Nineteenth Avenue looking south toward Maywood. A railroad employee, possibly the Melrose Park stationmaster, stands at the far right of the photograph.

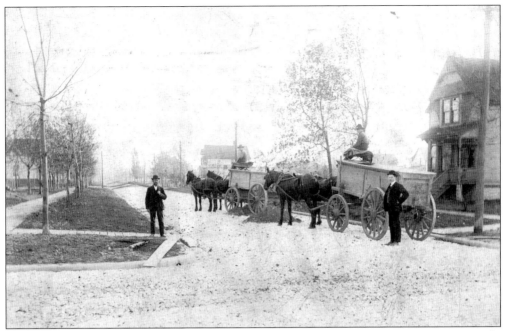

In early 1900, the village of Melrose Park began the process of paving many of its dirt roads. Pictured above is prominent pioneering citizen David Allen (left), the builder of one of the first homes in Melrose Park, checking on the progress of street pavers on what appears to be North Seventeenth Avenue.

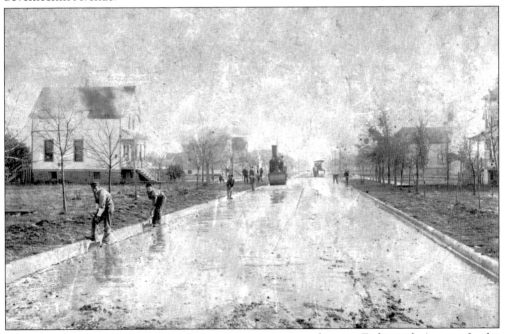

This photograph from about 1900 depicts a paving crew working on Eighteenth Avenue. In the background, old-fashioned steamrollers appear to be leveling the street surface. The paving of the main streets formally signaled Melrose Park's transition from a rural prairie town to a bustling suburban community boasting many modern amenities at the dawn of the 20th century.

Although many Melrose Park streets were paved by 1904, the modernization apparently had not caught up to the southeast corner of Nineteenth Avenue and First Street where the Barstith home was located. Note the wooden sidewalk, the horse and buggy, and the Chicago and Northwestern Railway station in the background. The Schoenhofen sign on the brick building reflects the German heritage of many of the area's earliest settlers.

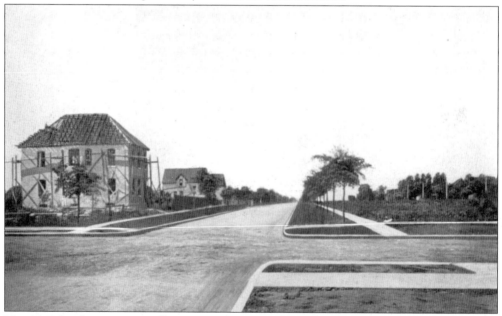

Housing developments rapidly sprung up around newly planned neighborhoods. This neighborhood at Twenty-second Avenue, looking north from Lake Street, featured concrete sidewalks and recently planted curbside trees. The carefully graded street stands ready for paving, while the vacant lots across the street await the construction of new homes to satisfy an increasing demand for quality housing.

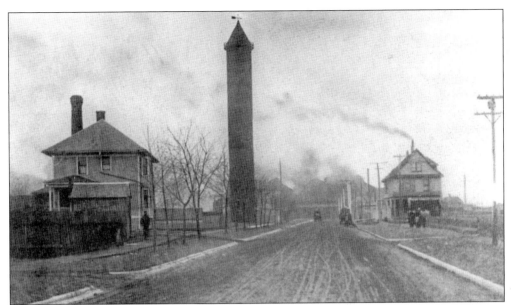

This photograph depicts the Melrose Park Waterworks in 1905. Located on Main Street near Twenty-third Avenue, this water tower measured 110 feet high, and the well went down 1,800 feet. The pumping station supplied the town with fresh water in the days before Lake Michigan water was piped into the area.

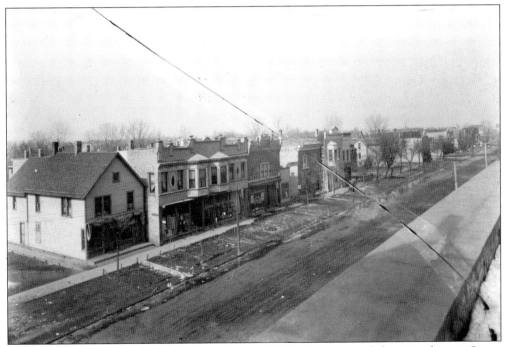

By 1904, Broadway Avenue had developed into a thriving business and shopping district. Stores and offices line the street in this photograph, taken by early-resident William Barstith using a large bellows camera with an 8-by-10-inch glass plate. A number of these buildings remain standing today.

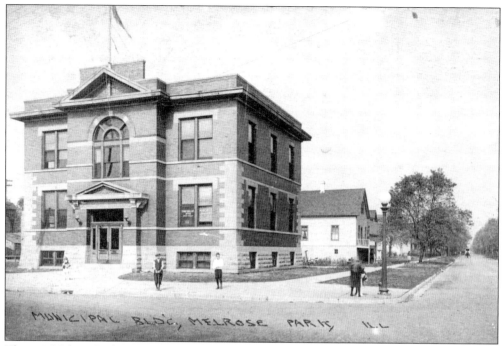

The new Melrose Park municipal building, erected in 1908, stood on Lake Street near Eighteenth Avenue. In addition to housing village government offices, the building also included the library, the courthouse, and the police department.

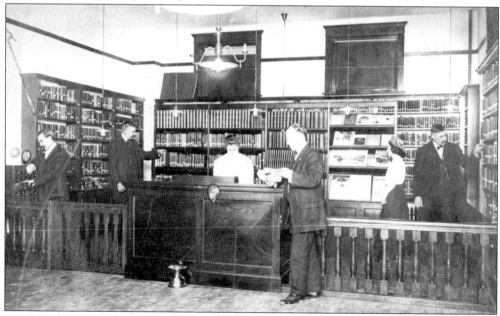

Local residents, from left to right, Walter Smith, E. M. Atherley, Eve Smith Caffero (librarian), G. C. Paynton, Bessie Smith, and C. W. Widney peruse the small but ever-growing Melrose Park Public Library collection in 1908. With the library conveniently located in the village hall, patrons could conduct business as well as check out books. A handy spittoon is located in front of the checkout counter.

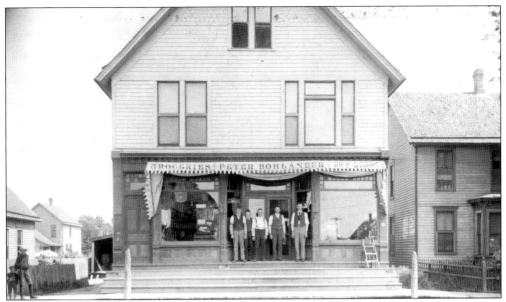

The general store was a popular gathering place for early Melrose Park residents. Peter Bohlander's General Store (pictured in 1885) also doubled as the Melrose Park Post Office. The store, which sold a wide range of groceries and dry goods, stood on the east side of Nineteenth Avenue near First (Main) Street, a rapidly developing business area. The hitching post in front of the store was essential for out-of-town customers who travelled to town for shopping visits in wagons, carriages, and on horseback.

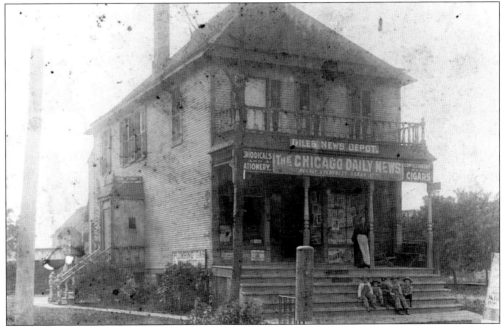

Children gather on the steps of the Giles' News Depot where cigars, tobacco, periodicals, stationary, and newspapers could be purchased. The *Chicago Daily News* was a popular choice; according to the advertising slogan pictured here, "Nearly everybody reads it." The building, located at 6 Nineteenth (Broadway) Avenue, also housed a plumbing supply store.

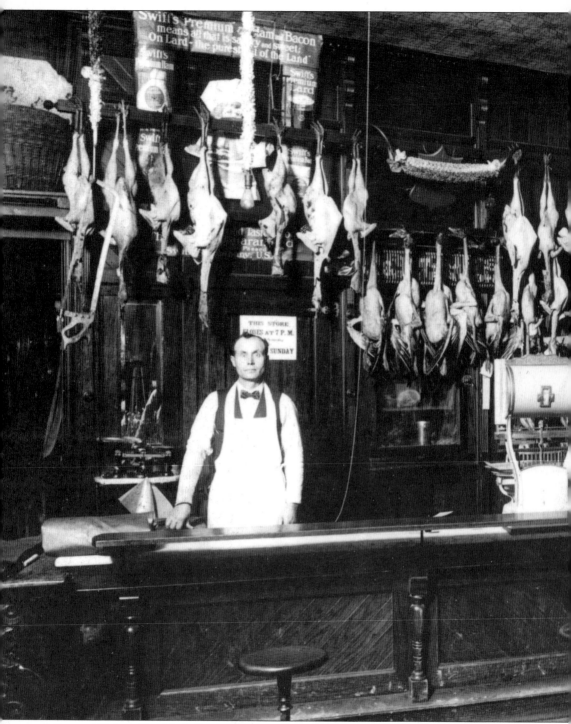

Julius and Robert Trenkler's Grocery Store is pictured here in 1903. Trenkler's was located on the northeast corner of Nineteenth Avenue and First (Main) Street. In addition to purchasing poultry, customers were sure to find plenty of Swift's Premium Ham and Bacon, which, according to the sign in the upper left-hand corner, was "all that is savory and sweet." In an advertisement

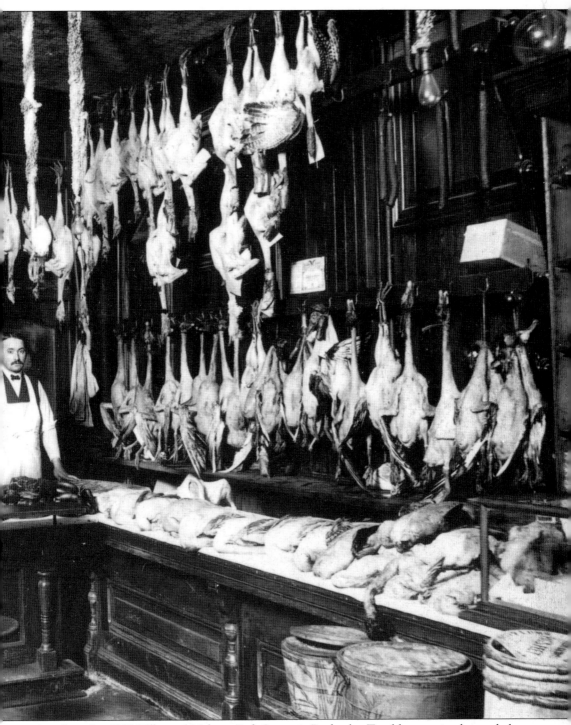

placed in the *1907 Village of Melrose Park Souvenir Book*, the Trenkler cousins boasted that they were "purveyors to all who want good things to eat." Julius Trenkler originally worked for Peter Bohlander and, after forging a partnership with his cousin Robert, purchased Bohlander's grocery and meat department in 1903.

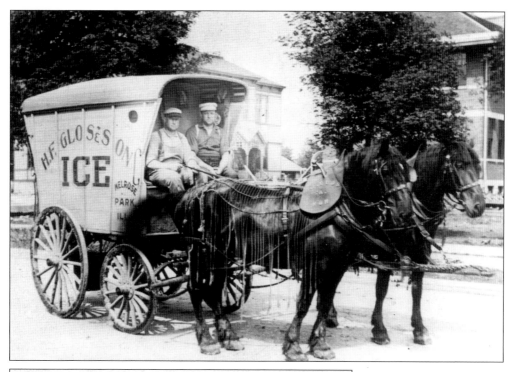

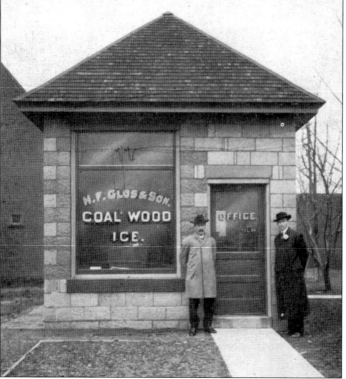

In an era that predated electric refrigeration, the ice wagon was a familiar sight along Melrose Park streets. Housewives concerned about spoilage eagerly awaited the arrival of the iceman. Pictured (above) around 1905 is the H. F. Glos and Son Ice Wagon on Eighteenth Avenue just north of Lake Street. Henry Glos, born in 1860 in what is now Bellwood, originally opened his business in Maywood in 1888. In 1890, he moved to Melrose Park, where he established an office (left) on Twentieth Avenue and Railroad Street. In addition to ice, Glos provided coal and coke to area customers.

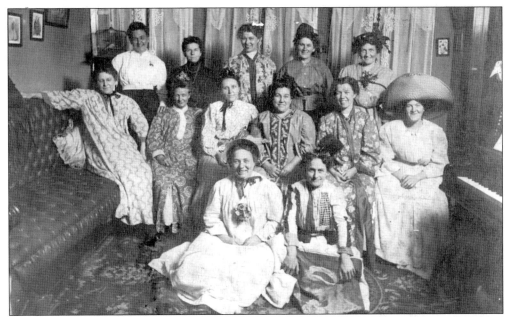

Social life was very important in early Melrose Park. Pictured here around 1900, a group of Melrose Park women gather in the front parlor of a local home for a kimono party. Judging by their broad smiles, rare in photographs of this period, it looks as if a good time was had by all. Even in small towns such as Melrose Park, oriental fashions, fabrics, and furniture were all the rage during the Edwardian era.

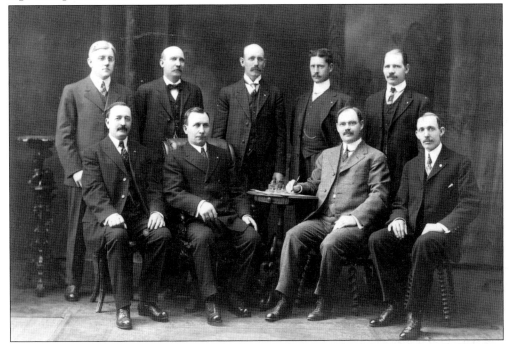

More typical of the formal, stylized portraiture of the era is this 1900 photograph. Here an appropriately serious-looking group of Melrose Park government officials stiffly poses for a group portrait without cracking a smile.

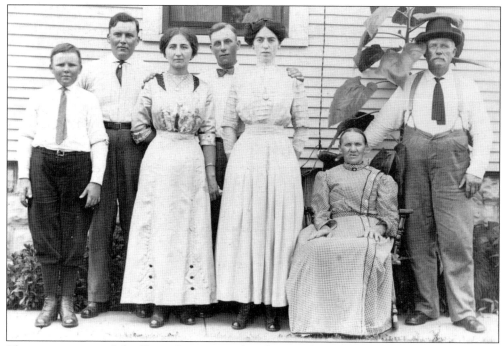

Three generations of the Haag clan, a typical Melrose Park family from the dawn of the 20th century, gather in front of their home on North Eighteenth Avenue for a formal portrait. (Courtesy of Ralph Tolomei.)

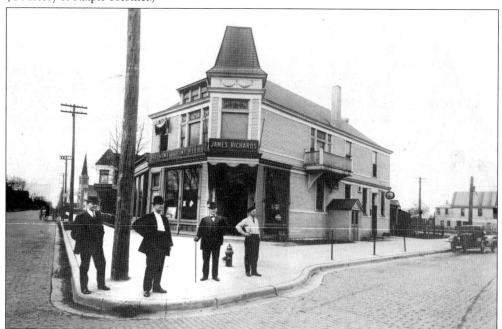

James Richards, proprietor of the Home of Fine Beers, and a group of dapper-looking friends gather on the newly paved corner of Ninth Avenue and Lake Street in approximately 1900. The steeple of St. Paul's Lutheran Church, located on Eleventh Avenue and Lake Street, can be seen in the background.

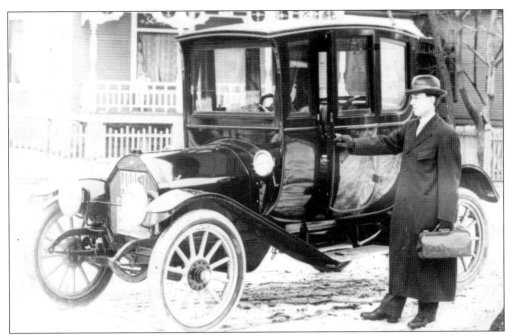

In addition to running his busy local medical practice, prominent civic-minded citizen Dr. Paul B. Kionka (pictured in front of his automobile) was the village health commissioner, a director of the Citizen's State Bank, and the first president of the Melrose Park Public Library board.

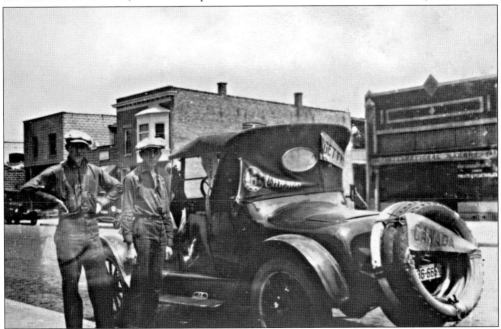

Automobiles eventually replaced the horse and buggy in early Melrose Park. This Model T Ford was able to park curbside—without the benefit of a hitching post—on Broadway Avenue around 1927. Many automobile owners decorated their automobiles with pennants representing the cities they had visited. It appears as if the owners of this particular Model T may have traveled to Canada, Gettysburg, New York, and Chicago.

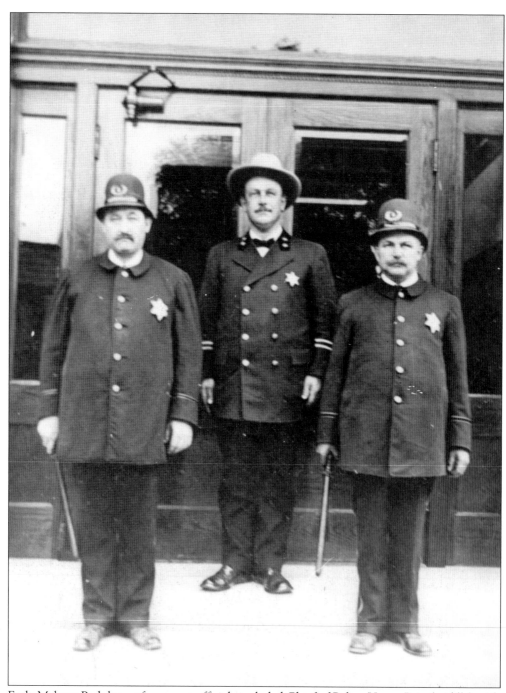

Early Melrose Park law enforcement officials included Chief of Police Henry Pein (middle) with two of his officers around 1915. Pein was appointed the first official chief in 1914 and served in that capacity until 1929. Previous to his tenure, Melrose Park's top cop was called the marshal and police officers were referred to as deputies.

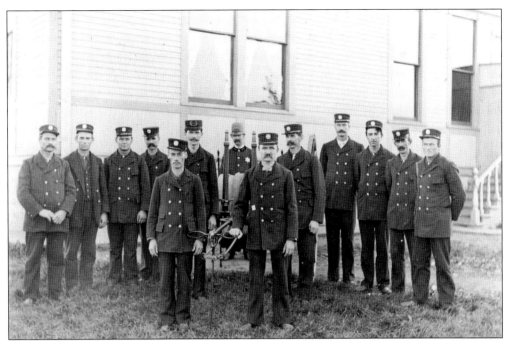

The original firefighters of Melrose Park pose with their two-wheel tank and hose cart about 1895. The fire department, chartered in 1895, relied on hand-drawn and horse-drawn carts until 1913 when it purchased its first motorized fire truck.

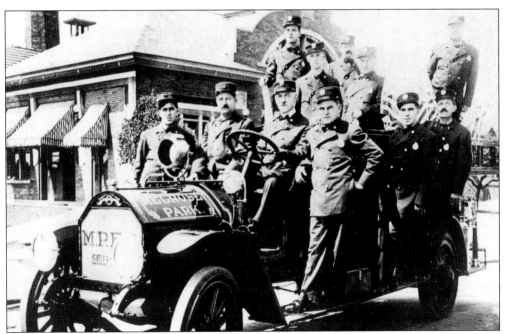

In 1913, a group of firefighters poses proudly with their first motorized fire truck in front of the newly constructed Melrose Park Waterworks, located at 2300 Main Street. Firefighters pictured include Ed Prignano, Walter Hart, Joe Ftezner, Bill Engbrecht, Herman Jedike, Phil Smith, Herman Puttkamer, and Harry Blake.

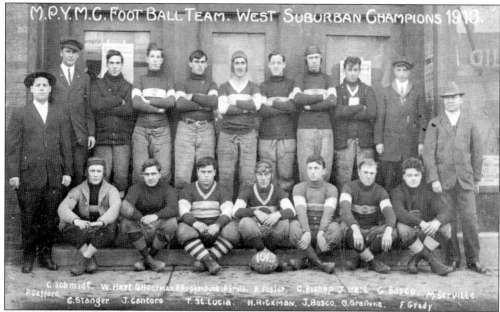

Athletics played an important role in the early days of the village. Pictured above is the Melrose Park Young Men's Club football team, West Suburban Conference champions, in 1913. Pictured from left to right are (first row) C. Stanger, J. Cantore, T. St. Lucia, H. Ritzman, J. Bosco, G. Greinke, and F. Grady; (second row) P. Caffero, C. Schmidt, W. Hart, G. Hoerman, P. Reggenbuck, P. Smith, R. Foster, C. Bishop, J. Hart, G. Bosco, and M. Servillo.

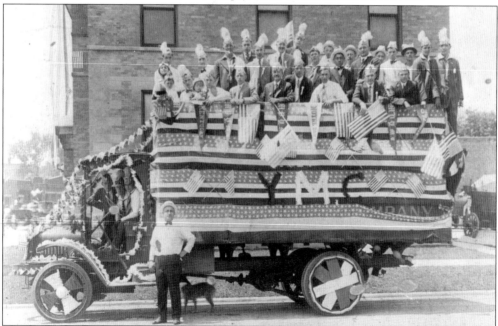

The Fourth of July parade and picnic was a cherished tradition in early Melrose Park. In 1916, members of the Melrose Park Young Men's Club decorated a float with college pennants; red, white, and blue streamers; and American flags. They posed in front of the village hall for a group photograph. Pictured standing in front of the truck is Nick Bosco.

Traditionally a close-knit community, Melrose Park citizens gathered together to mourn as well as to celebrate. Pictured below, a host of grieving mourners line Broadway Avenue to view the funeral procession of local submariner Charles Calcott (right) on January 11, 1928. Calcott was killed when Coast Guard Cutter CG 17, on loan from the navy to prevent Prohibition-era rum-running, collided with his submarine, the S4, on December 17, 1927, off the coast of Provincetown, Massachusetts. In addition to Melrose Park residents, hundreds of sailors attended the funeral and a U.S. Navy honor guard led the blocks-long procession down Broadway Avenue.

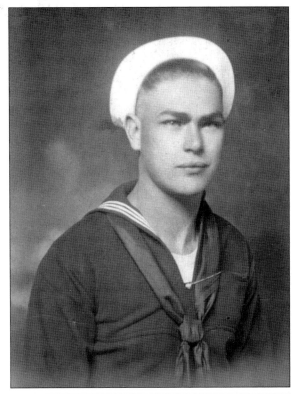

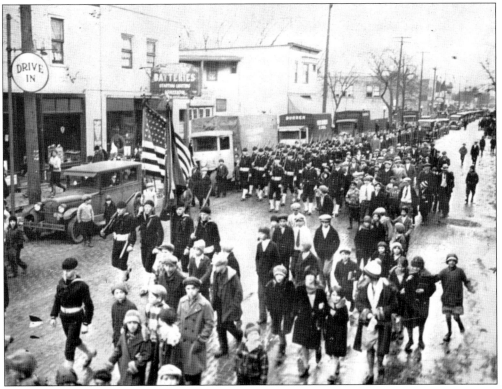

G. H. BOHLANDER

DEALER IN

Builders' Hardware,
House Furnishings,
Stoves, Pumps,
Paints, Oils
and Glass.

❧

AUTOMOBILE SUPPLIES

❧

Buggies, Wagons, Harness
and Agricultural
Implements

❧

112 Nineteenth Ave.
MELROSE PARK, ILL.
Telephone 7292

H. Wachtendorf

~

Bakery
and
Confectionery

~

141 Nineteenth Avenue

MELROSE PARK

TELEPHONE 776

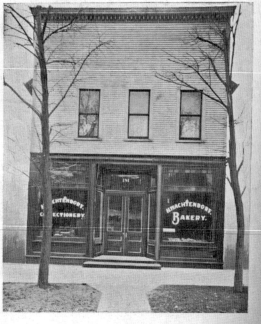

A variety of local merchants placed advertisements in the *1907 Village of Melrose Park Souvenir Book*. Pictured here are advertisements for pioneer retail establishments G. H. Bohlander Store and the Wachtendorf Bakery.

Two

FAITH AND EDUCATION

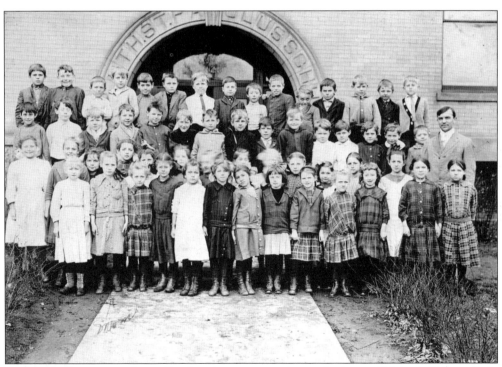

Faith and education traditionally played important roles in the lives of Melrose Parkers. Early residents relied on church and school institutions to provide spiritual guidance, educational opportunities, and social activities. One of the first civic actions early citizens took was to raise money to build church and school buildings. St. Paul's Lutheran Church and School (originally named St. Paulus) was established by German immigrants in the 1880s. Pictured here in 1914, students and teacher M. J. Weiss pose in front of the distinctive arched doorway of St. Paulus.

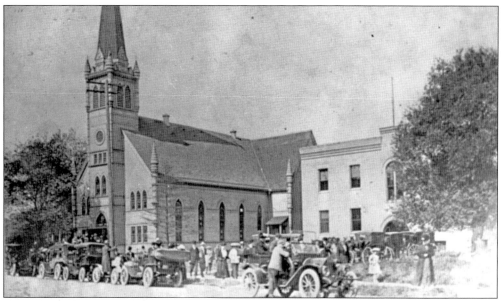

St. Paul's Lutheran Church was one of the first churches established in Melrose Park. A congregation of the faithful gathers in front of St. Paul's Church on a Sunday morning in 1911. Although automobiles were beginning to make inroads in the village, many churchgoers still traveled to services in horse-drawn carriages. St. Paul's School stands directly to the right of the church on Lake Street. Both church services and school classes were conducted in German until 1919.

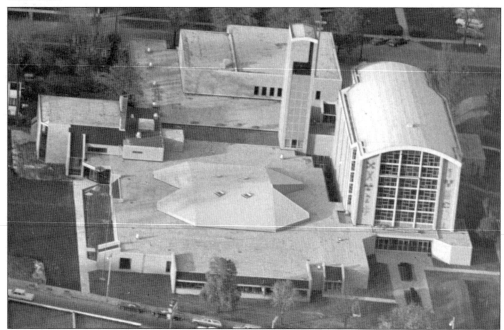

A new St. Paul's Church was built in 1958. This aerial view of the modern structure, taken shortly after the dedication, stands in stark contrast to the traditional design of the previous building. The bell tower located directly to the west of the church was removed in 1993 due to a loss of structural integrity.

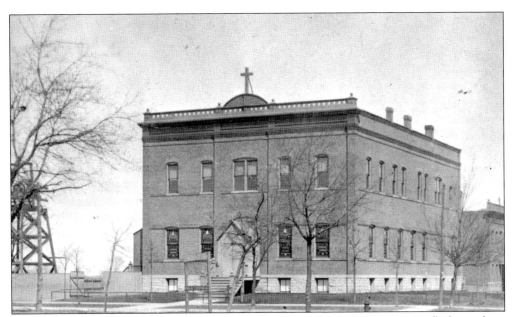

Sacred Heart Catholic Church was founded in 1893. The building (pictured), located on Sixteenth Avenue and Rice Street, was built in 1901. It housed the school, the convent, and the church. After the new church was built in 1955, this multipurpose building was used as classroom space for the middle grades.

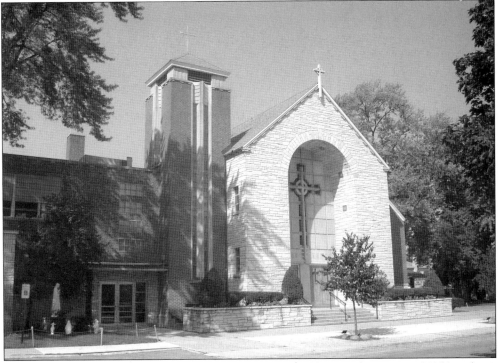

Construction began on the new Sacred Heart Church building in the spring of 1954 and was completed in October of that same year. Built on the site of what was formerly a baseball diamond, the church building now stands on the corner of Fifteenth Avenue and Iowa Street.

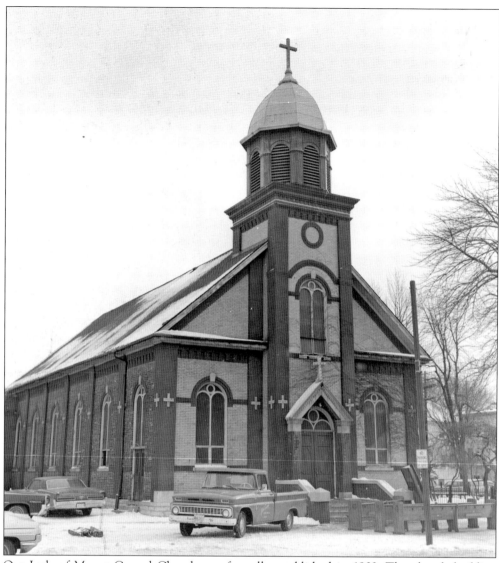

Our Lady of Mount Carmel Church was formally established in 1903. The church building pictured here on Twenty-third Avenue and Augusta Street was built in 1908. Originally founded to house the statue of the blessed virgin Our Lady of Mount Carmel, it continues to do so to this day. Our Lady of Mount Carmel remains the only national Italian parish in the archdiocese of Chicago.

The new Mount Carmel building, dedicated in 1968, includes a special chapel specifically designed to house the sacred statue of Our Lady of Mount Carmel. Mount Carmel School stands in the background. The school was closed in 2004 due to decreasing enrollment.

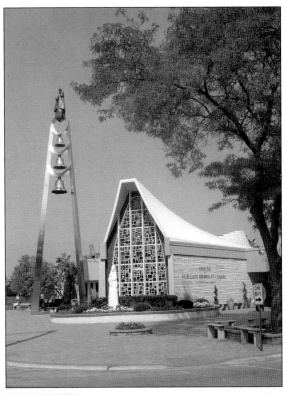

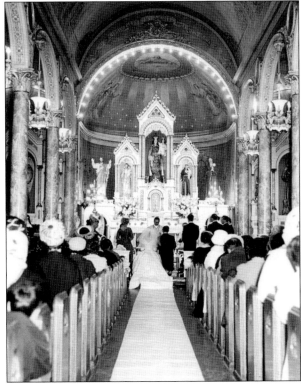

Barbara and Peter Giordano exchange wedding vows on November 3, 1962, in the old Mount Carmel church building. The interior of the church featured marble columns, an elaborate dome decorated with frescoes, and a statue of Our Lady of Mount Carmel. This statue was preserved and is currently located in the shrine of Our Lady of Mount Carmel. (Courtesy of Barbara Giordano.)

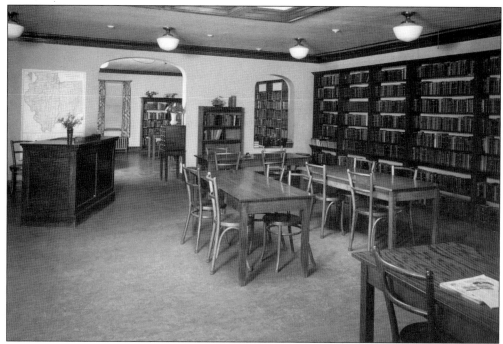

The library was an important educational institution in Melrose Park. Taken in 1940, this photograph depicts the interior of the library when it was located above the old Melrose Park firehouse on Eighteenth Avenue.

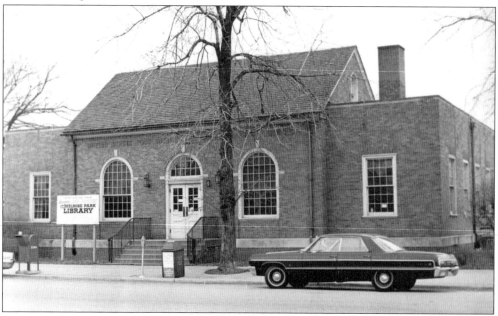

Pictured in approximately 1970, the old Melrose Park Post Office, located at 801 North Broadway Avenue, stands ready to be converted into the new Melrose Park Public Library. Built in 1935, this post office was replaced by a more modern structure on Twenty-fifth Avenue. The new Melrose Park Public Library opened on October 10, 1971, replacing the old facility situated above the firehouse on Eighteenth Avenue.

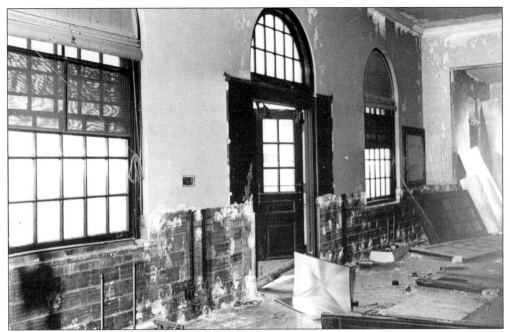

This photograph depicts the interior of the old post office shortly after the demolition process began. Many old-time residents remember the beautiful arched windows and entranceway that graced the original building. Restoration and preservation were not in vogue during this era when many vintage buildings were replaced by modern structures.

This photograph was taken in 1971 shortly after the conversion of the Melrose Park Post Office into the Melrose Park Public Library. Few remnants of the more classically styled post office remain, as copper sheathing and a stone facade cover the original brick exterior. The building has also been expanded to include the addition of a senior citizens' commons on the east side.

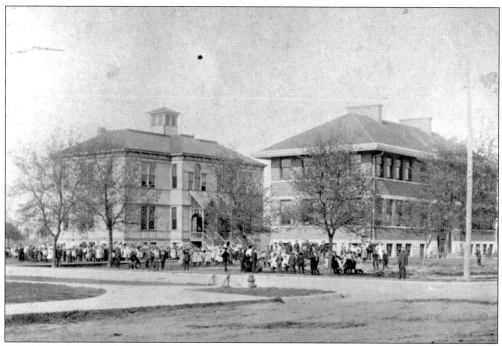

The old Melrose Park School, constructed almost entirely of wood, stands next to the newly completed brick school building on Lake Street. Students, parents, and faculty proudly gather in front of the two buildings in 1906.

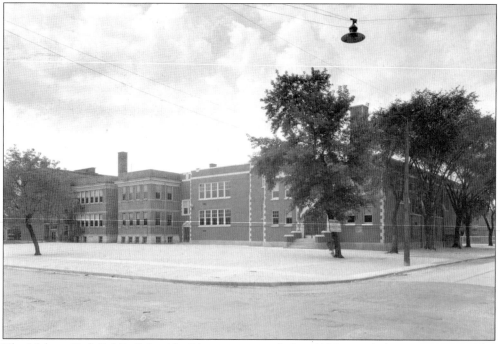

The Melrose Park Public School building was expanded in 1936 to include a gymnasium. The project, initiated under the auspices of the Public Works Administration, was officially known as Federal Works Project Illinois No. 1154.

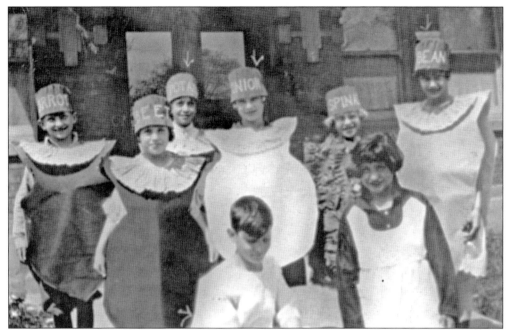

Melrose Park School students participate in a health play in 1924. The nutritionally conscious members of Miss Tanton's class pose as a carrot, a beet (Isabelle Drucker), a potato (Ross Cortino), an onion, a leaf of spinach, and a bean. Jane Zito stands in the lower right-hand corner of the picture.

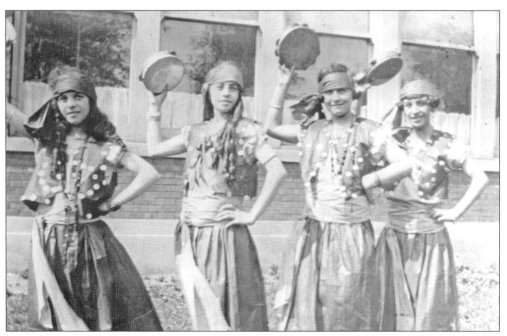

It was not all work at the Melrose Park Public School, especially for students in Mrs. Swanson's class. This quartet of girls dressed as gypsies looks like they are having plenty of fun as they cheerfully wave their tambourines for the photographer around 1924.

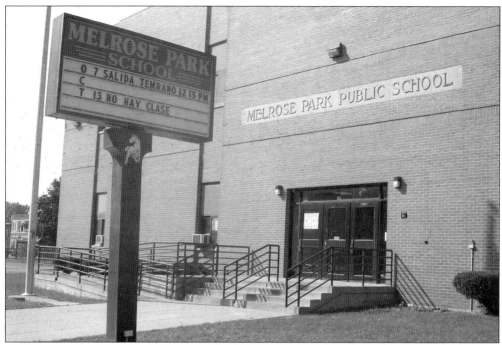

Enrollment at the Melrose Park Public School has expanded significantly since the 1980s due to the rapidly changing demographics of the community. Signage in both English and Spanish reflects the arrival of Hispanic immigrants with school-age children to the community.

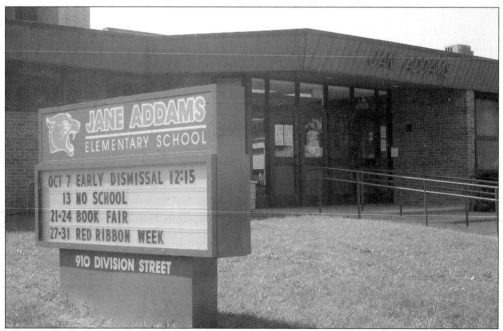

The Jane Addams Elementary School is located at 910 Division Street. Built to accommodate the influx of young families in the newly constructed Winston Park subdivision, it opened in the fall of 1960. It remains the newest elementary school in Melrose Park.

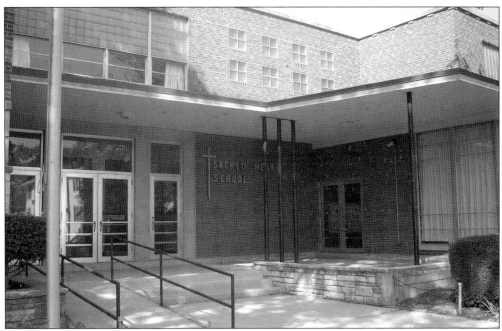

Sacred Heart School, the oldest Catholic elementary school in Melrose Park, opened on September 7, 1900. The second floor of the church/school building was destroyed during the 1920 Palm Sunday tornado. An entirely new church and school campus was built in 1951 at 815 North Sixteenth Avenue. Pictured here is the primary grade school building.

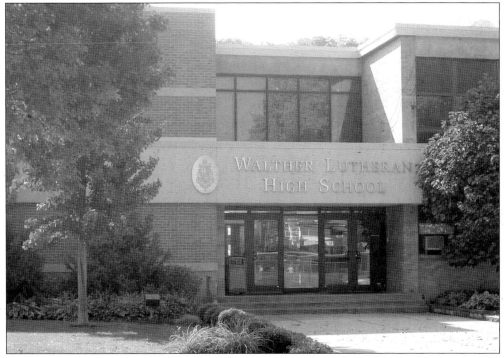

Walther Lutheran High School is the only secondary school located in Melrose Park. The school, located on the corner of Ninth and Chicago Avenues, opened in 1954.

SCHOOL DISTRICT NO. 89
REPORT OF PUPIL'S WORK

Parents will please sign and return this report promptly.

Name *Max Swaigsne*

School *Melrose Park* Grade *8 13*

From *Nov. 24, 1924* to *Jan. 23, 1925*

Days present *31 ½* Days absent *1 ½*

Times tardy *0* Conduct *85-*

Effort *85-* Reading *85-*

English *85-* Spelling *85-*

Penmanship *80* Grammar *85-*

Civics *80* History

Arithmetic *80* Music *85-*

Drawing *95-* Hygiene

Physical training Science *Geog 80*

Nurse's report

Mrs. Edna B. Moncreiff
Teacher

Mother

Chas Swaigsne
Father

Promoted to 18

Pictured here is young Max Swaigsne's second-quarter report card from the 1924–1925 school year. Swaigsne appears to have been a good student, and according to the comment written by teacher Edna B. Moncreiff on the bottom of the report card, he was promoted to the next level of the eighth grade.

Three

HOMES AND
NEIGHBORHOODS

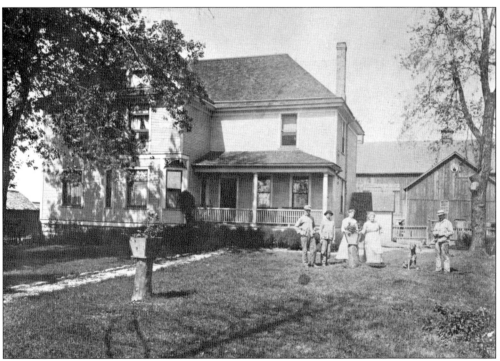

Originally a prairie stop on the Chicago and Northwestern Railway, the first homes to be erected in Melrose Park were scattered farmhouses. As the community grew, so did the number and the variety of homes. The Messenbrook family is pictured in front of their homestead on September 9, 1914. From left to right are Henry Messenbrook, Alvin Ernst Messenbrook, Hulda Messenbrook, grandma Hinz Messenbrook, family dog Rover, and Erich Hoeppner.

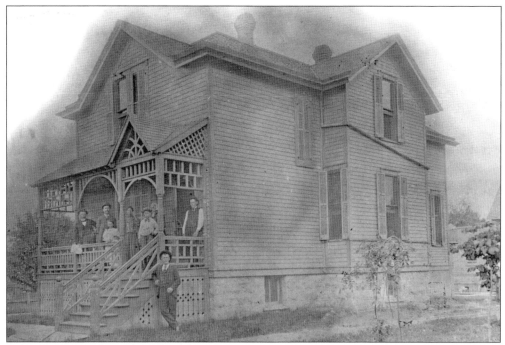

In 1898, the John DeBus family poses on the beautifully ornate porch of their home on the west side of Nineteenth (Broadway) Avenue. They were joined by Henry Pein, standing in the foreground. John DeBus was a Village of Melrose Park trustee from approximately 1892 through 1901.

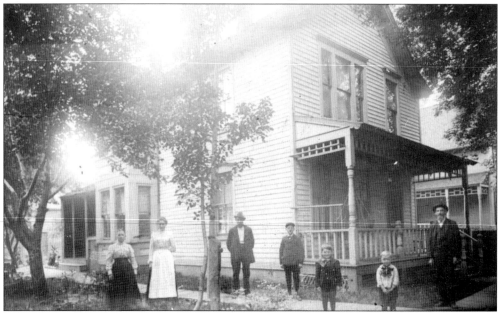

Pictured around 1900, the Samuel E. M. Allen house was built about 1873. The Allen clan was a prominent pioneering family in early Melrose Park. Samuel E. M. Allen served as the village clerk and as a village trustee during the late 19th century. Interestingly, this home was originally built without a concrete foundation, resting solely on cedar posts. Around 1925, the house was raised, placed above a more substantial foundation, and a basement was added to the existing structure.

Depicted are two more early Melrose Park residences belonging to members of the extensive Allen clan. At right (around 1900) is a house built by Grandpa Allen. Grandma Allen is on the porch, Aunt Nettie poses in the doorway, and young Beulah Allen stands barefoot on the stairs. Below (around 1900) is the home of Richard and Rachel Allen at 134 North Fourteenth Avenue. With the addition of a hammock, many front porches doubled as sleeping porches in an era that predated air-conditioning. Richard, David, and Samuel Allen were founding members of the Melrose Prohibition Club No. 2 of Proviso Township.

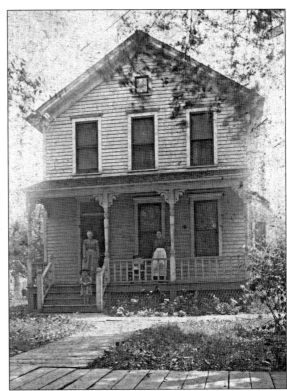

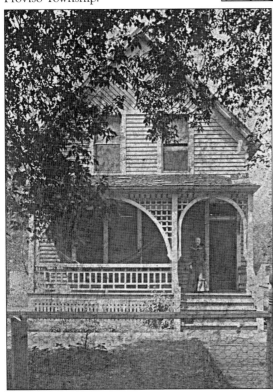

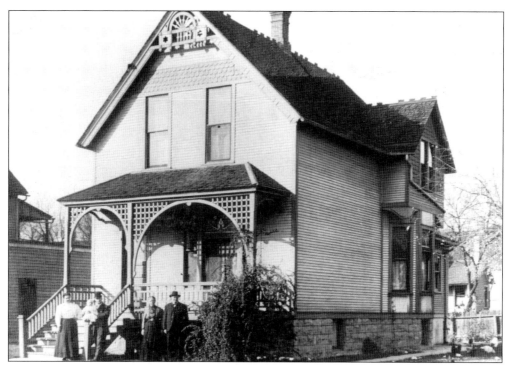

Pictured here in approximately 1910, members of the extended Knippenberg family pose in front of their home located on Fifteenth Avenue and Superior Street. The ornately gabled roof peak seen on many vintage Melrose Park houses was a common Victorian architectural feature.

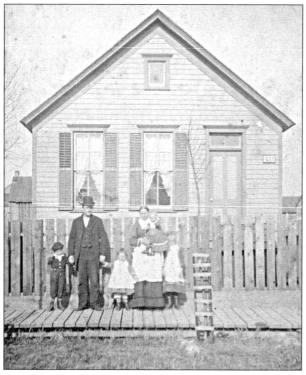

There was a wide range of housing styles in early Melrose Park. In this photograph, an unidentified family poses on the wooden sidewalk in front of their modest home at 433 North Broadway Avenue. Many working-class residents of the village lived in similar cottage-style houses.

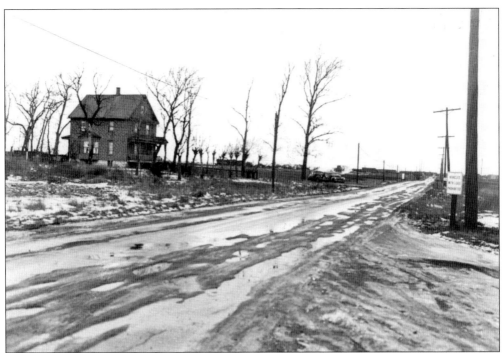

Two different views of what is believed to be the intersection of Twenty-fifth and North Avenues are pictured above and below. The isolated house pictured above and the businesses pictured below were eventually replaced by the Benjamin Moore paint factory. In the distance, a steam locomotive heads southwest on the Indiana Harbor Belt tracks. In the 1940s and 1950s, scattered residential housing on the north side of town was torn down as North Avenue became the hub of a burgeoning commercial and industrial district in Melrose Park and the surrounding suburbs.

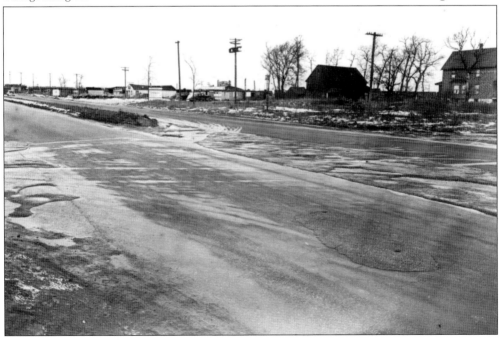

The post–World War II population boom created a need for quality housing in the Chicago suburbs. In the mid-1950s, ground was broken in the undeveloped northeastern section of Melrose Park to begin construction of the new Winston Park subdivision. The prairie land to be developed stretched from Division Street in the foreground all the way to North Avenue in the far distance.

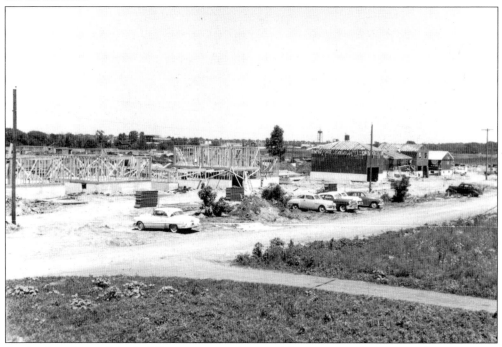

As the first phase of the building process commenced, homes in various stages of construction sprung up on and around Division Street. In this photograph, some homes already have siding and roofs, while others are mere frames resting on concrete foundations.

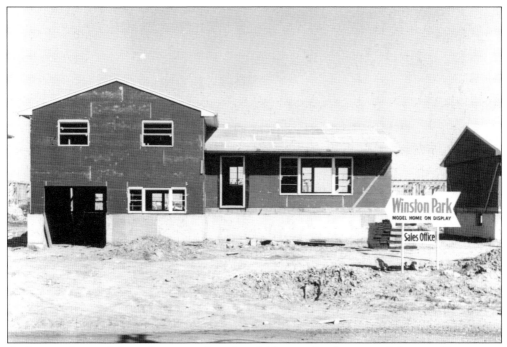

Architects designed three distinct styles of model homes for the new subdivision. Prospective buyers were invited to view display models of the Winston Park homes. Models included the smaller Ashley (depicted here in progress), the mid-sized Beverly, and the spacious Canterbury.

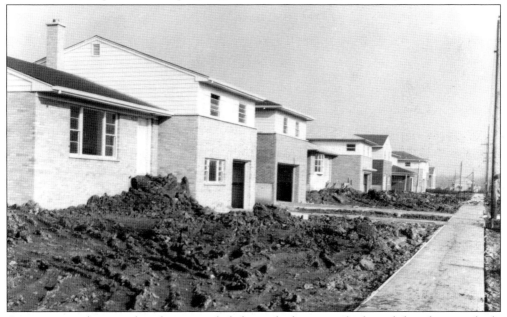

Amenities in these modern homes included attached garages, built-in dishwashers, multiple bathrooms, Melody Master Music Systems, and oak hardwood floors. Nearly completed, these split-level homes along Division Street typified the suburban architecture of the late 1950s. Although the sidewalks have already been laid, the landscaping and the driveways have yet to be finished.

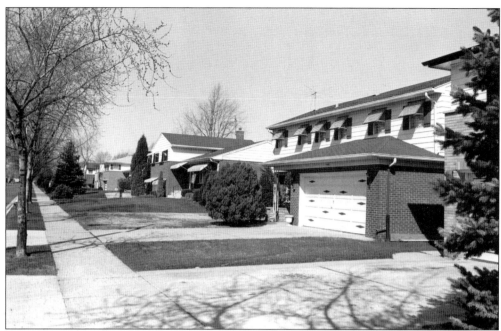

Buyers quickly snapped up these high-quality yet affordable houses; the first unit of 300 homes was sold out in three days. The subdivision soon evolved into a close-knit neighborhood, and the homes were so popular that a second building phase was initiated on the east side of Ninth Avenue.

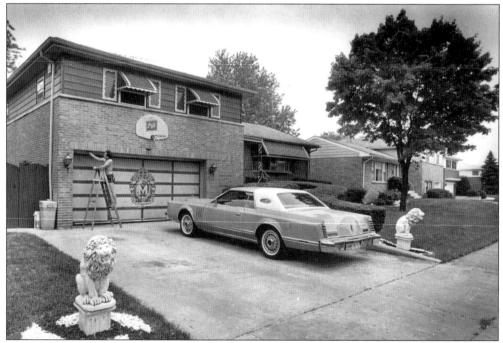

In the early 1980s, an unidentified Winston Park resident works on his garage at 1217 Winston Drive. The Schlitz Beer basketball hoop, the stone lions guarding the house, and the sporty Lincoln Mark IV parked in the driveway typify the idealized suburban lifestyle of that decade.

Sears mail-order homes were an early-20th-century phenomenon. These ready-to-assemble kit homes were shipped via rail. Since the Chicago and Northwestern Railway ran directly through town, early Melrose Parkers could easily take advantage of this inexpensive housing option. Pictured above is a cluster of three modest Sears homes identified by mail-order-home expert Rebecca Hunter. Located on the 1200 block of Seventeenth Avenue, the first and third homes are Starlight models, while the center home is a Sears model 2024. Pictured below on the 1100 block of Thirteenth Avenue is an example of the more-elaborate Normandy model.

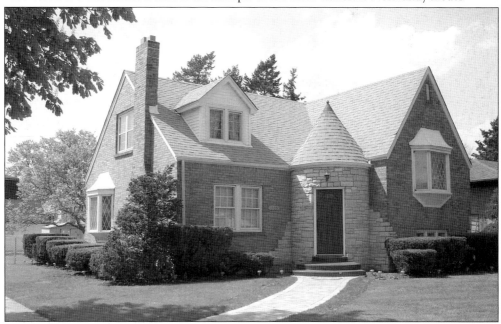

MELROSE PARK HOMES

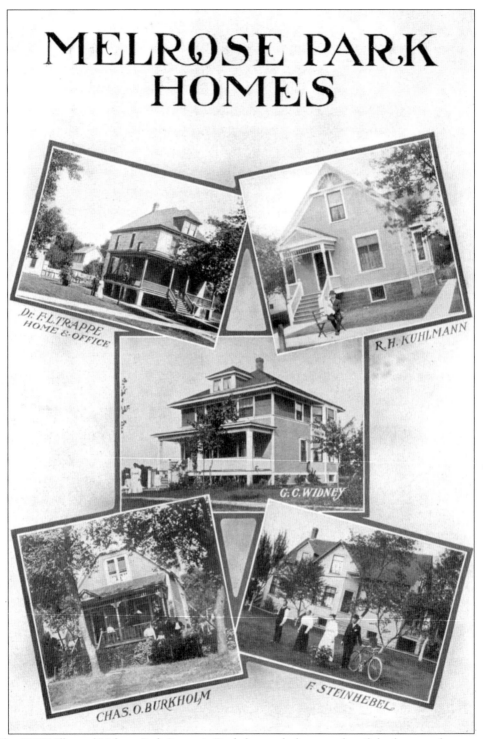

The *1907 Village of Melrose Park Souvenir Book* featured photographs of the homes of many of Melrose Park's prominent early residents. The homes pictured provide a representative sampling of architecture in Melrose Park at the dawn of the 20th century.

Four

CORNER STORES TO CORPORATE KING

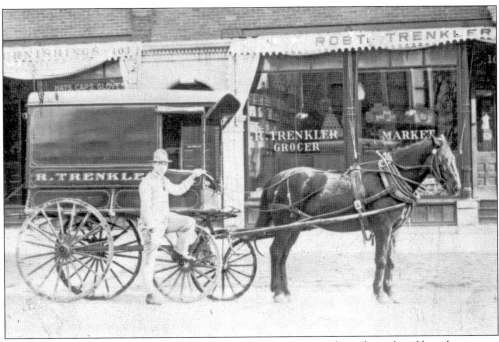

As the population of Melrose Park expanded and the town grew along the railroad line, businesses began to spring up on the prairie. Pioneering entrepreneurs often used horse-drawn wagons to display their goods and make deliveries to their customers. Although the Trenklers owned a storefront on Nineteenth Avenue and First (Main) Street, their delivery wagon was a common sight in Melrose Park neighborhoods.

Nineteenth (Broadway) Avenue was the heart of the early business district. In addition to Trenkler's Grocery, Mike Young Plumbing was also located on this bustling street. Pictured here about 1905 is Young's home and plumbing shop at 10 Nineteenth (Broadway) Avenue. Many small business owners and their families lived on the second floor above their businesses. Seated on the steps from left to right are Irene, Margaret, and Walter Young.

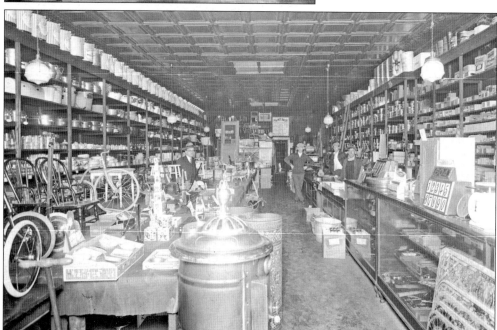

Willis Hardware Store was also located on Nineteenth Avenue. Pictured about 1906 is the interior of the hardware store, distinguished by the floor-to-ceiling shelves that remain standard in today's big box hardware stores. Manager E. C. Fish stands in the background. The eclectic array of items for sale includes bicycles, chairs, paint, and pots and pans.

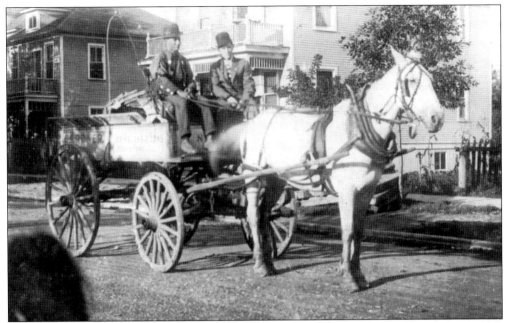

Louis Ragone (left) and Sol Prignano are pictured in the summer of 1914 atop Joe Ragone and Sons's wagon traveling north on Broadway Avenue. The Ragones raised produce on their family farm in Melrose Park. The wagon was used to transport the fresh produce to the South Water Market on Chicago's west side. The Ragones also sold firewood and garden supplies.

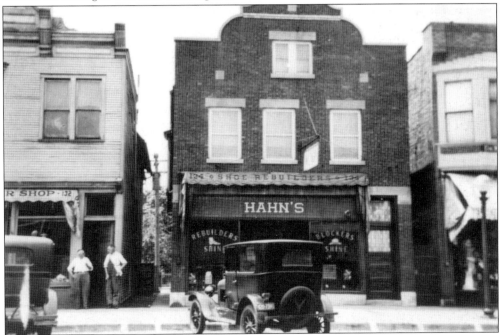

Hahn's Shoe Store was located at 134 Broadway Avenue. With the slogan, "Foot Fitters since 1890," the store not only sold shoes, but it also rebuilt them. In the yellow pages of the June 1925 *Telephone Directory of Maywood, Melrose Park, Bellwood and Hillside*, it advertised that it sold "shoes fitted by x-ray and high-grade hose."

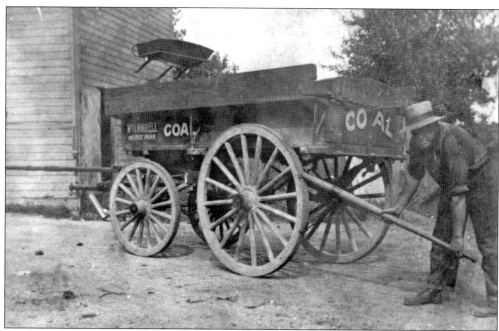

Historic Melrose Park businesses like the William G. Korrell Coal and Wood Company located at Twenty-third Avenue and Main Street initially relied on horse-drawn wagons (pictured above about 1900) to deliver supplies to homeowners and other businesses. By 1910, the Korrell Company put their horses out to pasture, replacing them with a modern delivery truck (below). In the early 1900s, most Melrose homes and businesses were still heated by coal furnaces and stoves, and the coal was delivered directly to basements via coal chutes. Korrell's company survived until 1953, by which time most buildings had been converted to gas or oil heat.

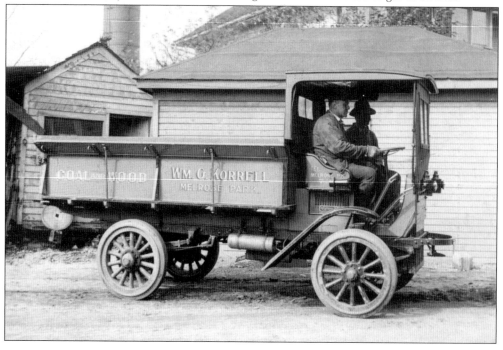

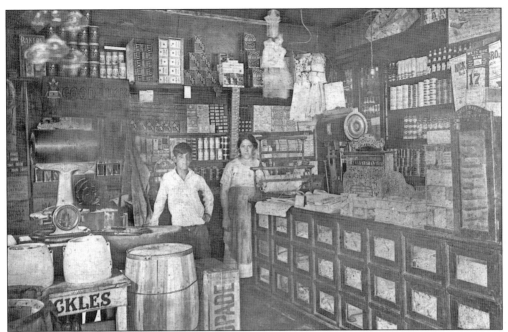

Mom-and-pop grocery stores were familiar fixtures in Melrose Park neighborhoods. Pictured here in 1921 is the interior of the Louis Pranno Store located in a side garage next to the Pranno house at 130 North Twentieth Avenue. Pranno's son Jack and his wife, Stella, pose amid the various goods and sundries for sale. (Courtesy of Diane Ravenesi and Ralph Ravanesi.)

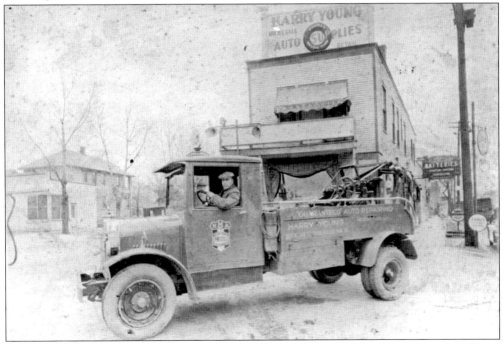

As cars became more common, automobile suppliers and repair shops began to replace livery stables and blacksmiths in Melrose Park. Harry Young and his tow truck are pictured in 1929 in front of Harry Young Wholesale Auto Supplies at 2009 Lake Street.

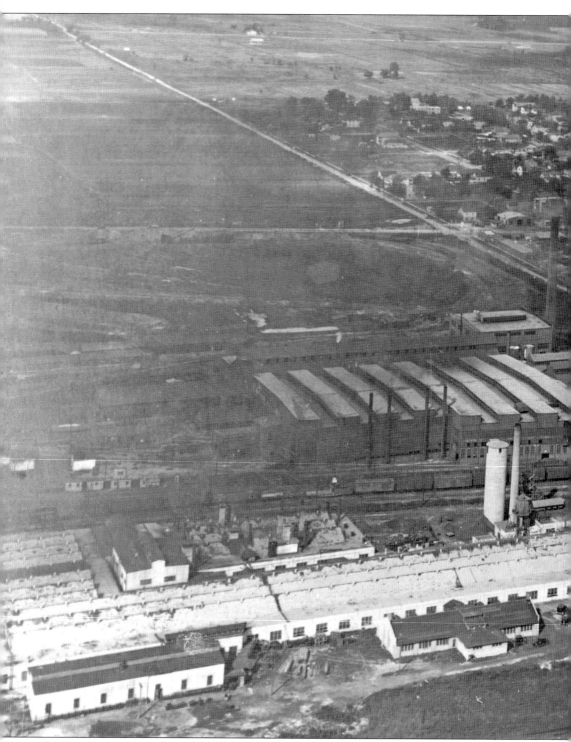

Melrose Park earned the nickname "Corporate King of the Suburbs" in the second half of the 20th century, as a string of industrial parks and retail businesses sprouted up along both Twenty-fifth Avenue and the North Avenue business corridors. Pictured above is an aerial view of the National

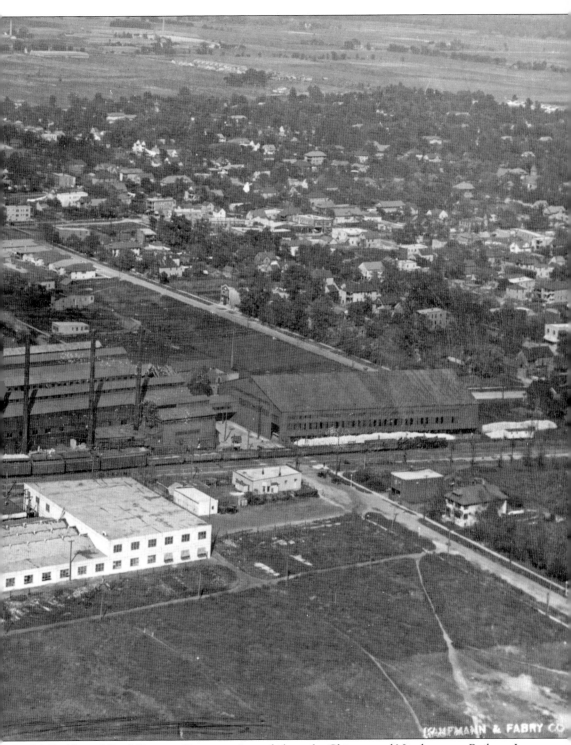

Malleable and Steel Castings Company situated along the Chicago and Northwestern Railway. In the far distance, farmland has yet to be developed. In the upper-right corner is the vacant prairie land that eventually became the Winston Park subdivision and the Winston Park Plaza.

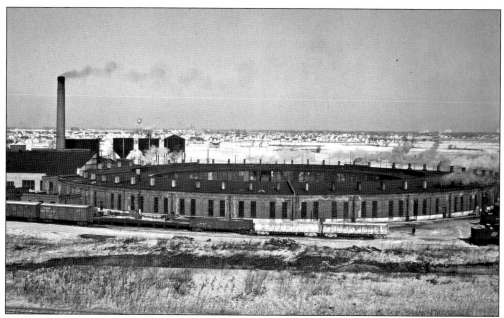

Railroads played an important role in the development of Melrose Park business and industry. The Chicago and Northwestern Railway roundhouse, located just south of Lake Street and west of Mannheim Road, was the largest roundhouse on the Northwestern system. (Courtesy of the Library of Congress, Prints and Photographs Division, FSA-OWI Collection, reproduction number LC-USW36-527.)

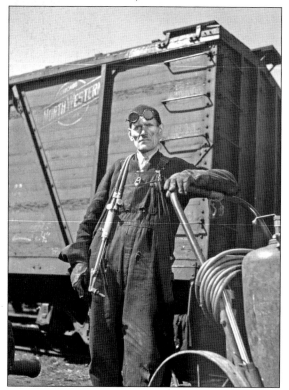

The railroad was one of the largest employers in the Melrose Park area. Pictured here in 1943 is welder Mike Evans at the RIP (repair-in-place) yard of the Chicago and Northwestern Railway in Melrose Park. (Courtesy of the Library of Congress, Prints and Photographs Division, FSA-OWI Collection, reproduction number LC-USW36-574.)

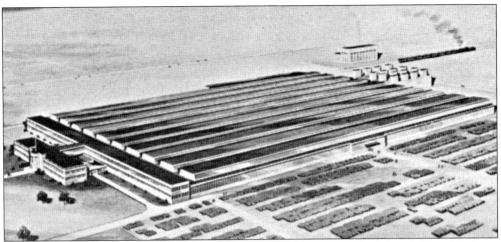

The advent of World War II precipitated the establishment of many war-related industrial plants throughout the country. The Buick Airplane Engine Plant, the largest defense project in the Chicago area, was located on the site of the former Nor-Mann Airport at Mannheim Road and North Avenue. The 1940 *Pictorial, Historical Review of Melrose Park, Illinois* book included this preliminary sketch of the plant.

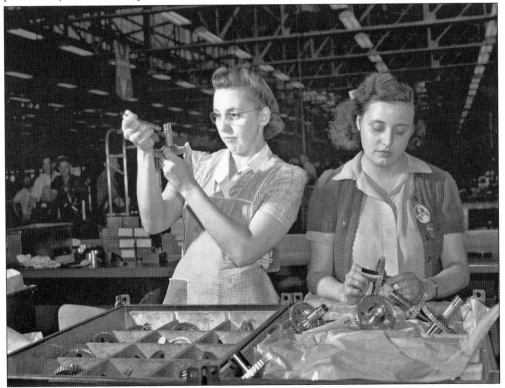

During the war, many women took jobs formerly held by men. Pictured here are two of Chicagoland's very own Rosie the Riveters, Dorothy Miller and Sylvia Dreiser. Miller and Dreiser are working the inspection line at the Buick Airplane Engine Plant in Melrose Park. (Courtesy of the Library of Congress, Prints and Photographs Division, FSA-OWI Collection, reproduction number LC-USE6-D-005584.)

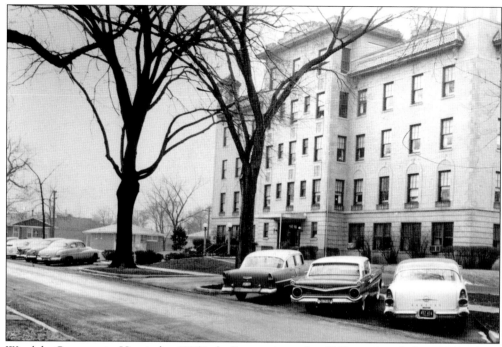

Westlake Community Hospital at 1225 Lake Street, pictured in 1957, was founded in 1925 by three local area doctors and was dedicated on May 12, 1927. The hospital has undergone four major expansions over the years. In 1998, it became part of the Resurrection Health Care Network.

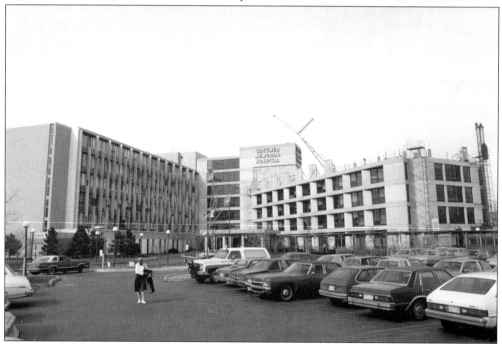

Gottlieb Memorial Hospital at 8700 North Avenue was founded in 1961. The hospital has grown from one small building to a 36-acre medical campus. Pictured in progress is a major expansion project in the early 1980s. In 2008, Gottlieb joined the Loyola University Health System.

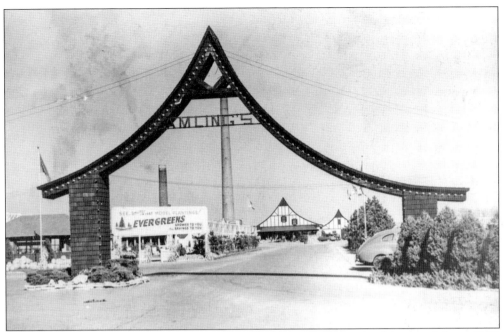

Founded in Melrose Park in 1899 by Albert Amling, Amling's Flowerland (pictured about 1940) was easy to spot because of its distinctive arched entranceway. Famous for its domed Bowl 'O Beauty floral displays, Amling's Flowerland, located at 8900 West North Avenue, was a popular destination for local gardeners.

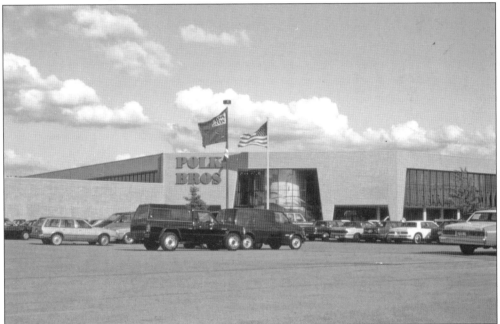

Polk Brothers Headquarters was located in Melrose Park at 8311 West North Avenue. The original Melrose Park building was completely destroyed by fire in 1987. This 1992 photograph was taken shortly before the company closed its doors forever. Today this building houses a Menard's Home Improvement store.

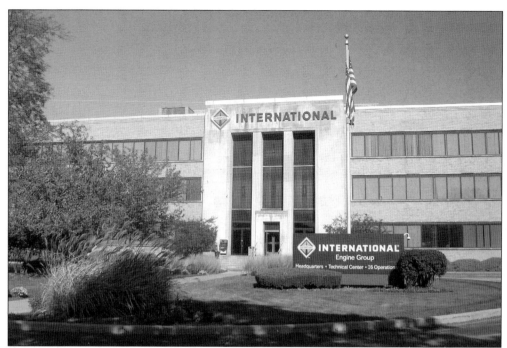

After World War II, many war-related industrial plants across the country were sold by the government and converted to peacetime manufacturing by private industries. The Buick Aviation Engine Plant at 10400 North Avenue was purchased by International Harvester. Today it houses Navistar's International Engine Group. (Courtesy of the Melrose Park Public Library.)

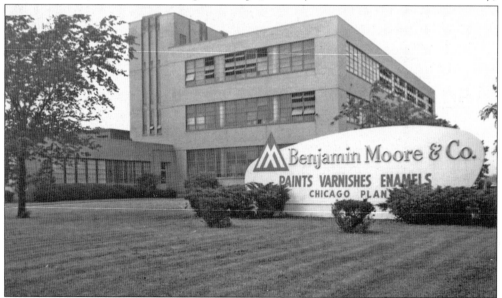

Construction of the Chicago branch of Benjamin Moore and Company at the intersection of North Avenue and Twenty-fifth Avenue in Melrose Park began in August 1949. The plant opened for operation in November 1950. This three-story facility was situated on 16.2 acres of land and provided many jobs for local residents. The plant was closed in 2002. This site was eventually redeveloped for retail use. (Courtesy of Benjamin Moore and Company.)

Broadway (Nineteenth) Avenue between Main and Lake Streets was originally the bustling retail center of early Melrose Park. After the advent of modern shopping malls like Winston Park, traditional downtown areas suffered a decline in business. Today, however, a rejuvenated Broadway Avenue houses a number of small independent groceries and shops conveniently located within walking distance of many neighborhood residents.

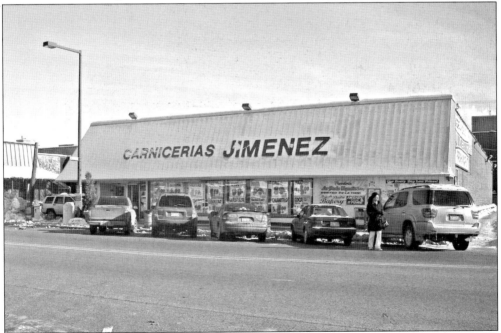

Jimenez Fresh Market/Carnicerias located at 717 Broadway Avenue is an example of a local business catering to the burgeoning Latino population in the Melrose Park area. The bilingual signage and Latino specialty products offered reflect the evolving demographics of the community.

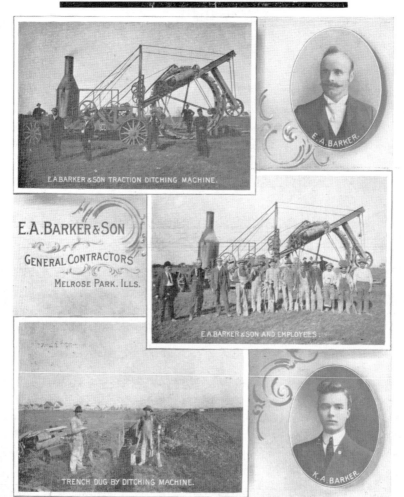

E. A. BARKER & SON
GENERAL CONTRACTORS

E.A.BARKER & SON TRACTION DITCHING MACHINE.

E.A.BARKER & SON
GENERAL CONTRACTORS
MELROSE PARK. ILLS.

E.A.BARKER & SON AND EMPLOYEES.

E.A. BARKER.

TRENCH DUG BY DITCHING MACHINE.

K.A. BARKER.

FIFTEENTH AVENUE AND FIRST STREET
MELROSE PARK, ILL.
PHONE 7261 MELROSE PARK

CONCRETE WORK STREET IMPROVEMENTS
CEMENT WALKS and FLOORS SEWERS and WATER MAINS

As the Melrose Park community grew around 1900 so did entrepreneurial opportunities for independent contractors and tradesmen. There were plenty of business opportunities for local contractors like E. A. Barker and Son to construct new homes and buildings, dig ditches, and work on street improvements. This advertisement originally appeared in the *1907 Village of Melrose Park Souvenir Book.*

Five

FOOD, FUN, AND FESTIVALS

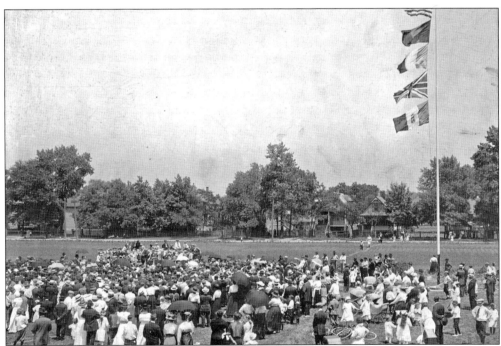

The Fourth of July has always been an important commemorative holiday for both longtime residents and for the ever-changing immigrant population in Melrose Park. In 1919, Melrose Parkers, dressed in their Sunday finest, gather to listen to local dignitaries on the Fourth of July. In addition to celebrating the nation's independence, they also paid tribute to a number of World War I allies. The flags displayed on the pole (from bottom to top) are those of Italy, Great Britain, France, Belgium, and the United States.

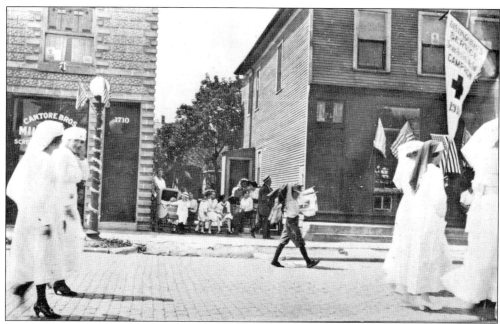

Parades were a common diversion in early Melrose Park. Pictured here in 1918, a group of proud Red Cross volunteers marches down Lake Street during a World War I Distinguished Service celebration. In addition to the light poles being decorated with streamers and flags, the children watching the parade are dressed in appropriately patriotic sailor outfits.

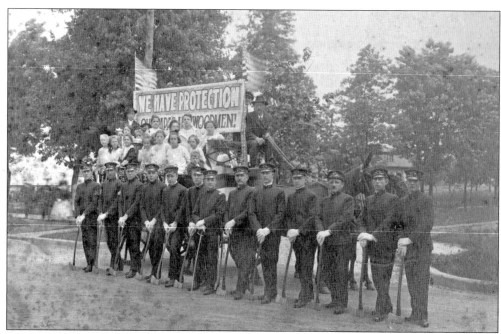

Many Melrose Park men were members of the Modern Woodmen of America, a national fraternal benefit society. The Melrose Park Camp No. 8449 was organized on October 11, 1901, with 15 charter members. As the society grew in popularity, the membership that included both prominent local businessmen and area workingmen expanded considerably.

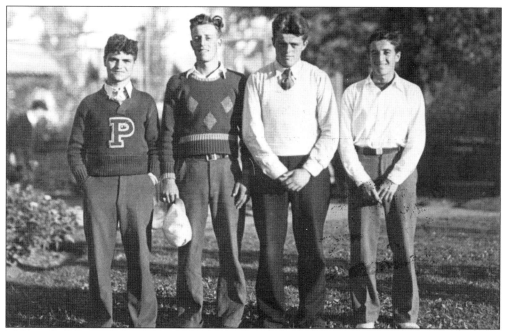

Melrose Park youngsters often worked as caddies at the Westward Ho Golf Club located at Wolf Road and North Avenue. Pictured above from left to right are caddies Vito Surico, Rocco "Silly Roc" Campanelli, Edwin "Heinie" Scherine, and Vito Nardiello, the winners of the 1934–1935 Chicago District Caddy Championship.

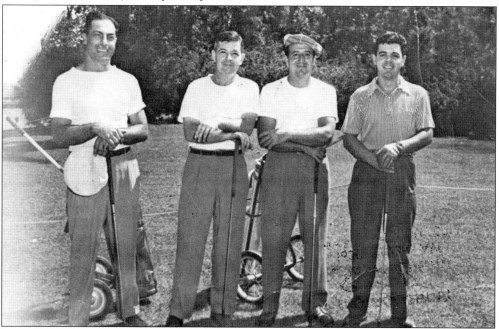

Finalists in the first annual Melrose Park Open held at Westward Ho Golf Club in 1954 included local residents, from left to right, Leo Pernice, Bill Daley, Nardiello, and Tony Yarro. Nardiello must have been a particularly good golfer, as he won both the 1934–1935 caddy championship and the Melrose Park Open 20 years later.

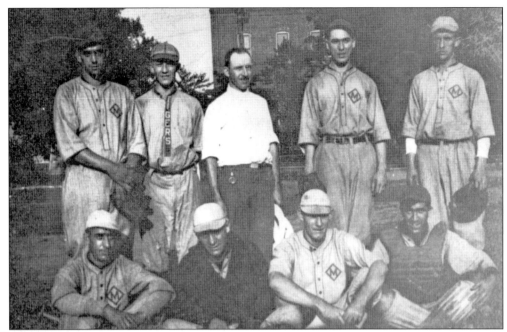

The National Malleable and Steel Castings Company baseball team, the Diamond Ms, is pictured across the street from Sacred Heart Church in 1918. Pictured from left to right are (first row) Tom Dugaw, Frank Werner, Carl Rebauch, and Phil Smith; (second row) George Perkins, unidentified, Les Dole, John Calcott, and L. Winkler.

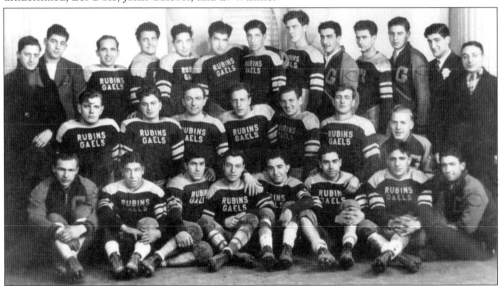

The original Melrose Park Gaels football team was founded in 1937. The Gaels are pictured here around 1940. From left to right are (first row) F. Loving, Tom Nicosia, Mike Celestino, Ralph Pasquerella, Joe Saviola, Angelo Provenzano, Rocco Paternoster, and Sam Nicosia; (second row) E. Yeager, Frank Belline, Gino Fiorarvante, Rocco Campanelli, Lou Bartemio, Pat Scavo, and Rudy Schroeder; (third row) Joe Belline, Marco Ortenzi, Andy Viglione, John Campanelli, D. Appuzzo, John Rago, Joe Nicosia, Ray Weiss, Frank Rago, Angelo Orlandino, Carmen Scudiero, Pat Lullo, and Fred Imundo.

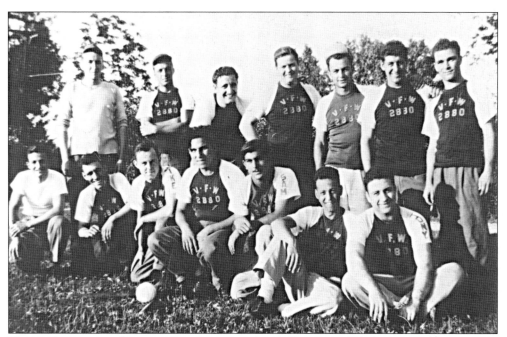

The 1949 Veterans of Foreign Wars Post 2880 baseball team included many Melrose Parkers. Pictured from left to right are (first row) George Pope, Bubs Seritella, Mike Belaski, Tony Cimino, Carm Ciminello, Nick Orrico, and Tony Ventrella; (second row) Marv Kolvitz, Clarence Rakow, Hugo Schneider, Ed Schueler, Al Acey, Jim Scanio, and Gene Surico.

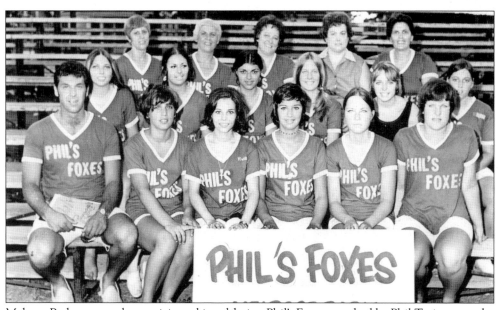

Melrose Park women also participated in athletics. Phil's Foxes, coached by Phil Torino, was the first all-female softball team in Melrose Park. Pictured here are members of the original team about 1960. (Courtesy of Mary Esposito.)

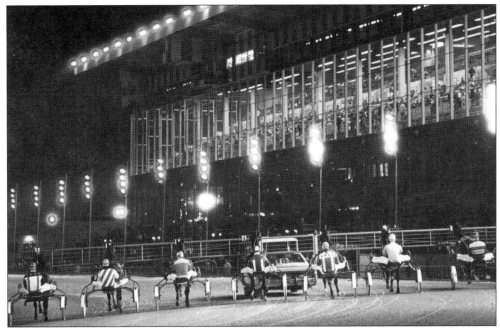

With the proximity of Maywood Park Race Track, located on Fifth and North Avenues, horse racing is a popular pastime for area residents. Opened in 1932 on the site of the former Cook County fairgrounds, Maywood Park Race Track features an enclosed grandstand, which allows for year-round harness racing.

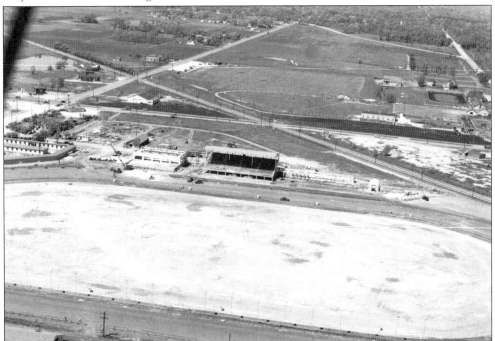

This undated aerial view of Maywood Park Race Track depicts the vast tracts of undeveloped land around Melrose Park. By the 1970s, much of this prairie land had been developed for commercial purposes. (Courtesy of the Franklin Park Public Library.)

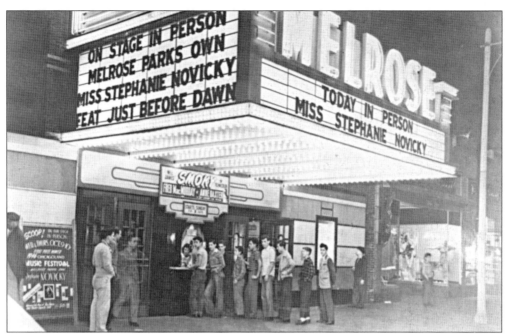

The Melrose Theatre, affectionately nicknamed "the Garlic Opera" by area residents, was located at 121 Broadway Avenue. This popular nighttime destination drew crowds from its opening in the silent film era to its final screening in 1972. Pictured here in 1946, customers line up to purchase tickets to see a live stage show featuring Stephanie Novicky.

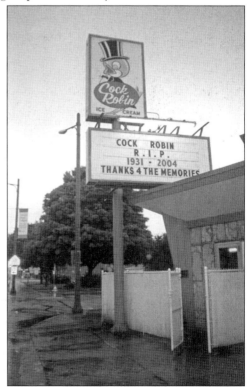

Famous for their square-shaped scoops of ice cream, Cock Robin was a Melrose Park institution and a popular teen hangout for 73 years. The Cock Robin located at 1315 Lake Street closed in 2004.

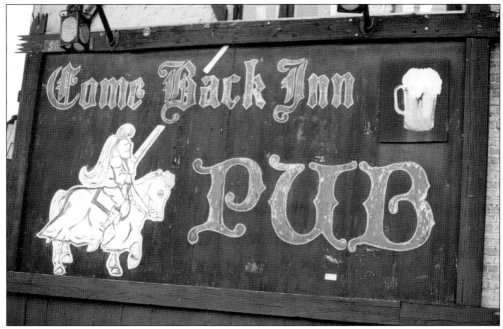

The Come Back Inn Pub, located at Lake Street and Broadway Avenue, was a popular Melrose Park eatery. Opened in the early 1960s, its interior was patterned after an Alpine hunting lodge. The warren of dimly lit rooms featured open fireplaces, mounted hunting trophies, and peanut-strewn floors. Visitors were greeted by a rotating bear guarding the entranceway.

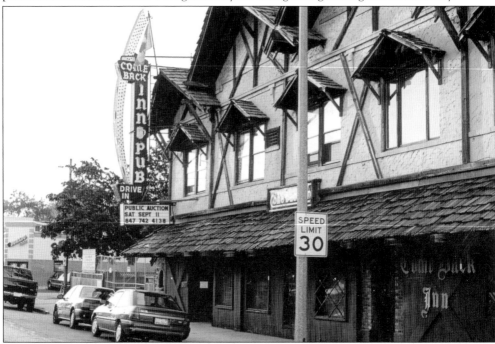

The Come Back Inn closed in 2004, and it was razed. Longtime residents have fond memories of tossing peanut shells on the floor, enjoying the unforgettable burgers, and visiting the Come Back Inn's Devil Home Catacombs in the basement.

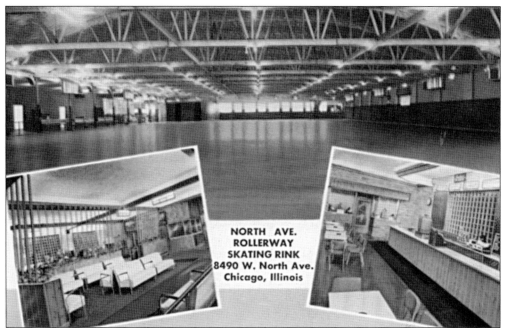

The North Avenue Rollerway Skating Rink was a favorite recreational hangout for generations of Melrose Parkers. Located at North Avenue and River Road, the rink was originally housed in a tent. The tent was eventually replaced by a permanent facility that was advertised as "the largest and most modern roller rink in the country." In addition to a beautiful rink that measured 237 feet in length, the building also included a snack bar, a pipe organ, a multicolored lighting system, and second-floor living quarters for its owners.

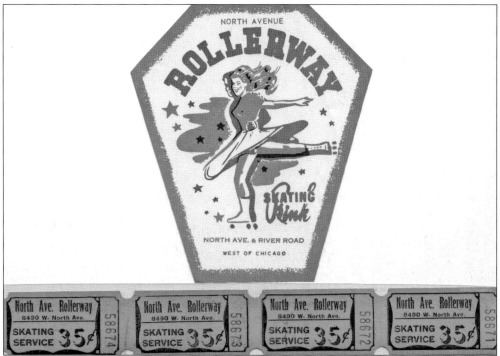

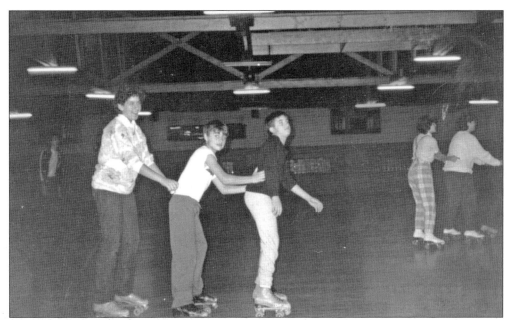

Skaters at the North Avenue Rollerway Skating Rink were encouraged to try a variety of dances and skating moves. The organ player, who also doubled as the emcee, designated the dance selections, which included the waltz, the fox-trot, couples only, ladies skate, and the bunny hop. Pictured in 1986 doing the bunny hop from left to right are Kim Esposito, Michael Kateeb, and Ralph Esposito. (Courtesy of Mary Esposito.)

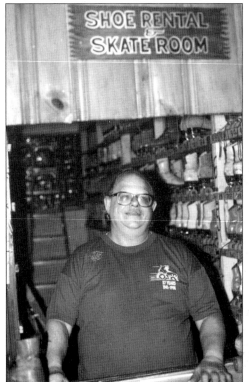

Mike "Rocky" Wachal was a familiar figure at the North Avenue Rollerway Skating Rink. He manned the shoe rental and skate room and ran the adjacent miniature golf course for many years. Many former patrons fondly recall the fact that Rocky always remembered the skate sizes of all the rink regulars.

Opened in 1929, Kiddieland Amusement Park, located at First and North Avenues, is the oldest amusement park in the Chicagoland area. Several generations of parents and children remember the excitement of spotting the distinctive Kiddieland marquee as they drove up North Avenue.

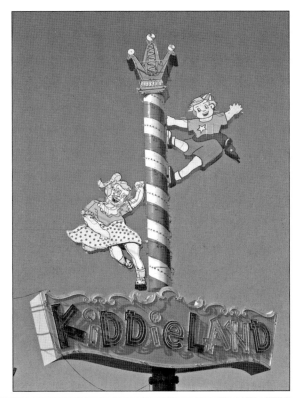

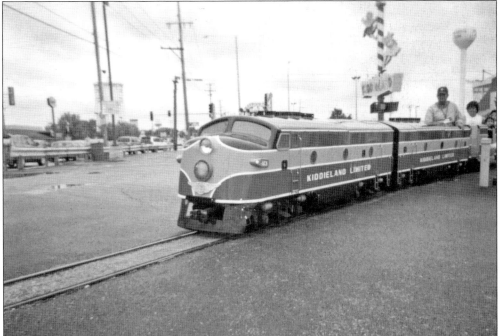

The Kiddieland Limited continues to be a favorite ride. Snaking its way leisurely around the park, this open-air train ride allows passengers to wave at cars driving down First Avenue while giving them a comfortable tour of the Kiddieland Amusement Park empire.

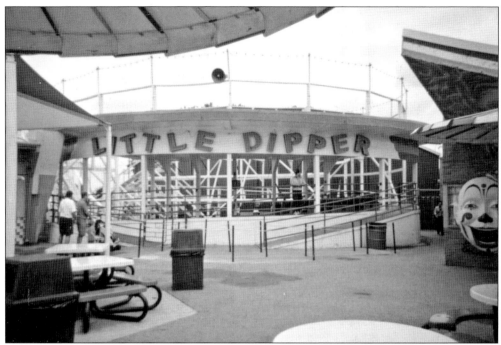

Who could ever forget their first ride on the Little Dipper? For many children, this small, wooden roller coaster introduced them to the exciting world of thrill rides. Kiddieland Amusement Park was and is noted for its array of age-appropriate rides for younger children.

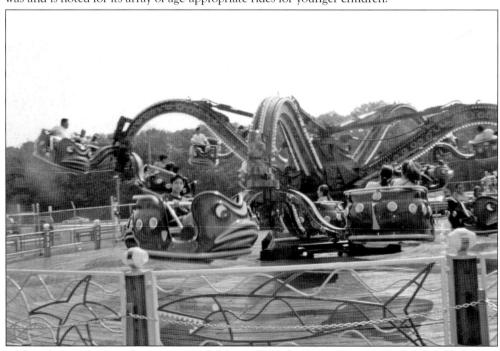

Although mainly geared to younger children, Kiddieland Amusement Park has added more teen-oriented rides over the years. The Octopus is one of Kiddieland's most dreaded thrill rides, especially for those with weaker stomachs.

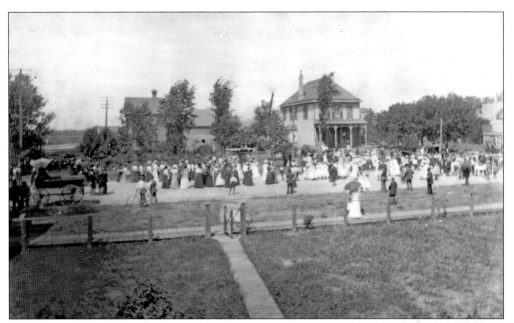

The Feast of Our Lady of Mount Carmel is one of the oldest and most sacred traditions in Melrose Park. First held in July 1894 to celebrate the Festa della Madonna, it provided Italian immigrants a needed link to the old country. Pictured here around 1904, Italian American pilgrims march down Broadway Avenue, heading toward Our Lady of Mount Carmel Church. The Melrose Park feast remains one of the oldest and largest in the nation.

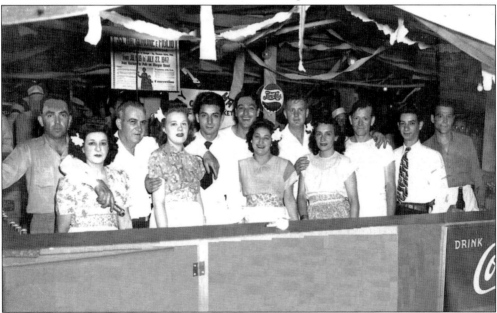

In addition to being a solemn religious occasion, the feast is also an important social event. Pictured here in 1947 is the beef and beer stand conveniently located directly in front of Our Lady of Mount Carmel Church. Pictured from left to right are unidentified, Mary Guadnagnali, Sam Guadnagnali, Bonnie Pranno, Louis Pranno, Peter Pernice, Esther Ariola, Robert Grotstuck, Rose Pranno, Bill Thompson, Anthony Pranno, and unidentified.

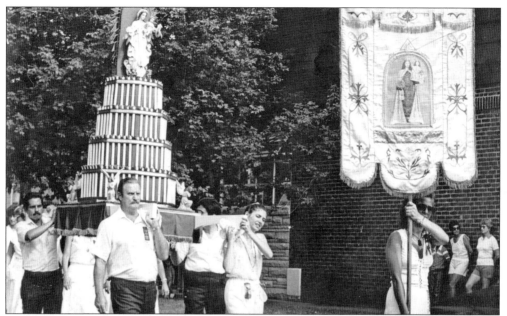

Our Lady of Mount Carmel's procession is the most identifiable component of the Festa della Madonna in Melrose Park. Thousands of the faithful annually march behind the statue of Our Lady of Mount Carmel. Many societies, sodalities, and families construct their own candle houses to be carried in the procession. Pictured in 1981, the Devotees of Our Lady carry their unique candle house along the procession route.

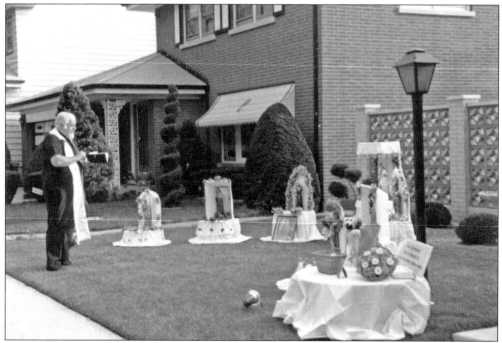

Many Melrose Park residents erect homemade altars or display icons on their lawns during the feast. Here Fr. Nick Mauro blesses the individual icons in front of the Dantino residence. The Dantinos are one of several families that create and display a beautiful new icon every year.

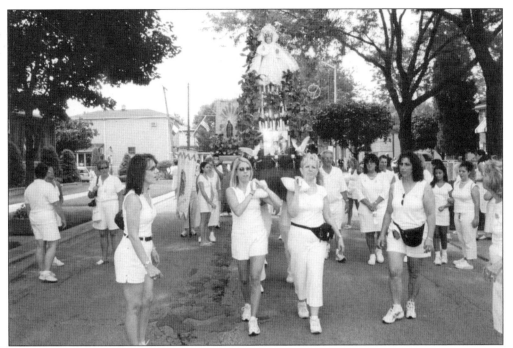

Individual groups of marchers often dress in their own distinct colors. Members and friends of the Cervone family dress in white to carry their candle house through the streets of Melrose Park during the procession. A statue of the infant Jesus of Prague sits on top of the candle house.

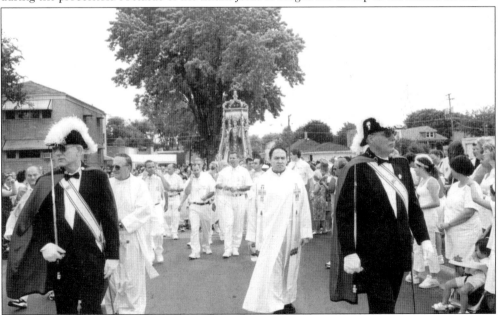

Escorted by the Knights of Columbus and carried by members of the Holy Name Society, the statue of Our Lady of Mount Carmel is the centerpiece of the entire procession. Approximately 50 members of the Holy Name Society take turns (16 at a time) carrying the elaborate statue throughout the three-hour procession. A large crowd of individual worshipers marches directly behind.

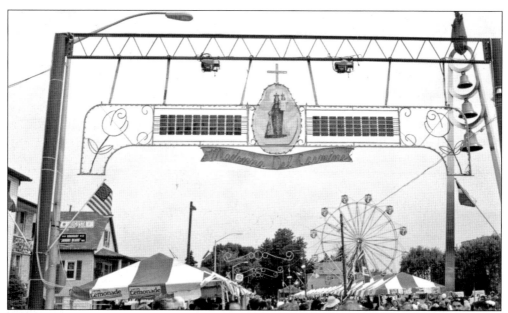

Feast attendees pass underneath a decorated archway set up in front of Our Lady of Mount Carmel Church. The archway, lit by festive colored lights, features a representation of Madonna Del Carmine (Our Lady of Mount Carmel). The feast is preceded by a nine-day novena and accompanied by a four-day carnival, featuring food, games, rides, and fireworks.

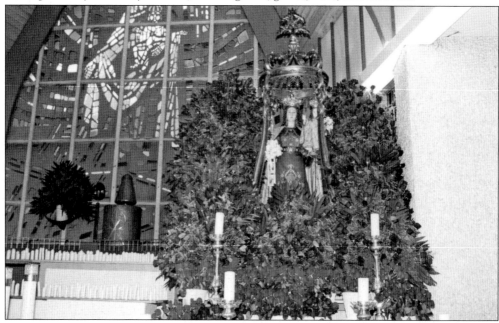

During most of the year, the statue of Our Lady of Mount Carmel is housed in a specially constructed chapel located inside Our Lady of Mount Carmel Church. On July 16, 2006, Thomas J. Paprocki, auxiliary bishop of Chicago, announced that Card. Francis George designated Our Lady of Mount Carmel as La Madonna del Carmine, a diocesan shrine. Pictured here, surrounded by roses, the statue is displayed on the main altar during the celebration of the feast.

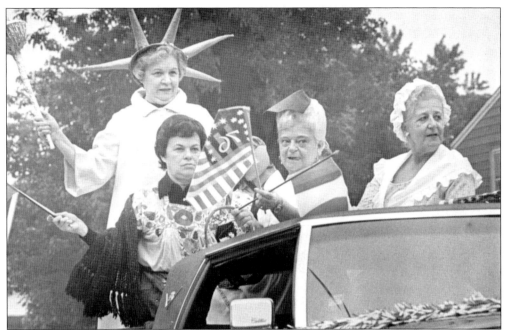

Melrose Parkers celebrated the bicentennial of the United States of America with a parade. Pictured here on a Lady Liberty float from left to right are Marge Liggett, Marilyn Tolomei, Marie Stacey, and Mrs. DiFrancisco. In a uniquely creative touch, the tinfoil-wrapped toilet plunger doubles as the torch of freedom.

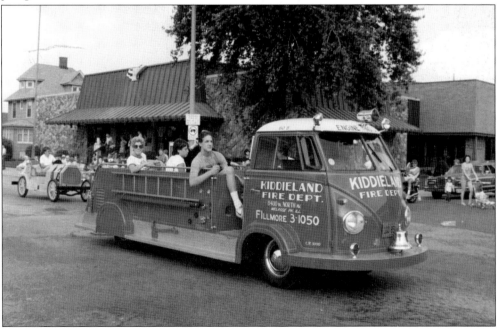

The Kiddieland Amusement Park fire truck was a familiar sight to area children. This pint-sized fire truck was dispatched to pick up groups of children attending birthday parties at the amusement park. Here the fire truck leads a local Melrose Park parade down Broadway Avenue. The building pictured in the background is the Melrose Park Public Library.

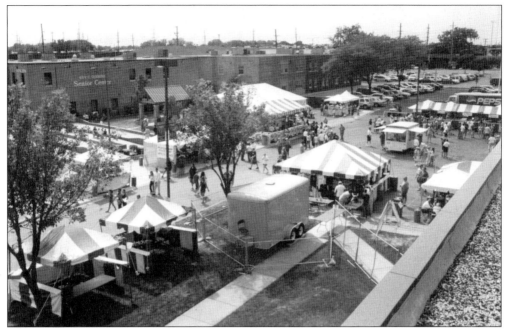

The Taste of Melrose Park is an important annual event in the village, drawing approximately 300,000 visitors every year. Inaugurated in 1981, it has become one of the most popular suburban food festivals in the Chicago area. Pictured is an aerial view of some of the booths set up on the grounds of the Melrose Park village campus.

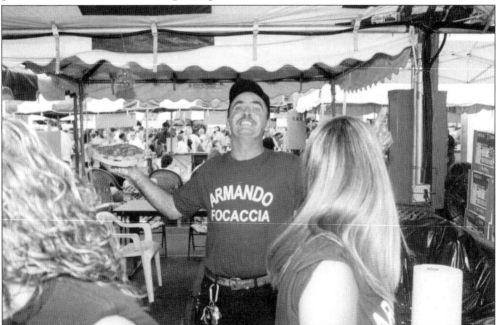

Popular ethnic specialties available include Melrose stuffed peppers, sfingi, artichoke casserole, rigatoni with vodka sauce, tiramisu, quesadillas, arinchini, bruschetta, eggplant parmesan, cannolis, and fried dough. Vendors and private citizens rent booth space to hawk their delicacies. Pictured here, Armando Ianelli displays his fresh-baked focaccia.

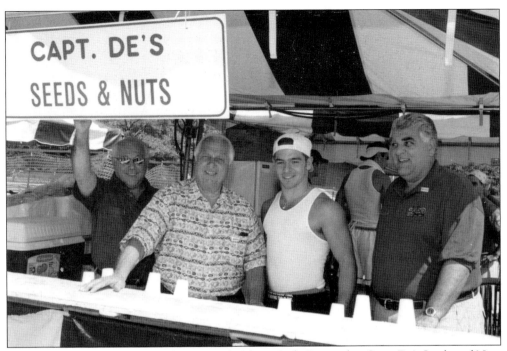

Celebrities are often spotted at the Taste of Melrose Park. Pictured at Capt. De's Seeds and Nuts stand is former Los Angles Dodgers manager Tommy Lasorda (second from left) with Melrose Park mayor Ronald Serpico (far right).

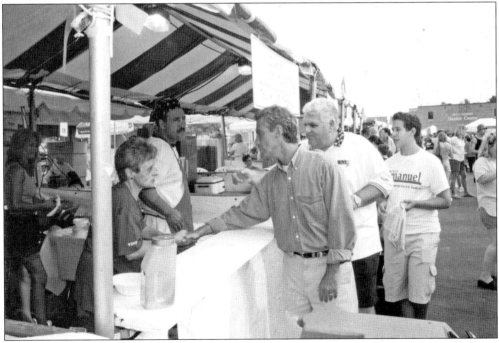

Prior to becoming Pres. Barack Obama's chief of staff, Rahm Emmanuel was one of many local politicians who visited the Taste of Melrose Park to shake a few hands and enjoy some of the ethnic specialties on hand.

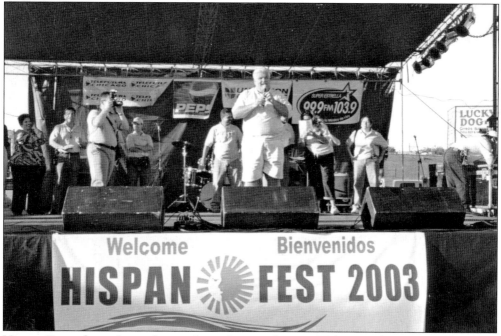

HispanoFest reflects the evolving ethnic demographics in Melrose Park. First established in 1989 to promote the development of the Hispanic community through education and outreach, HispanoFest is another popular community event. Pictured here, Mayor Ronald Serpico welcomes attendees to HispanoFest 2003.

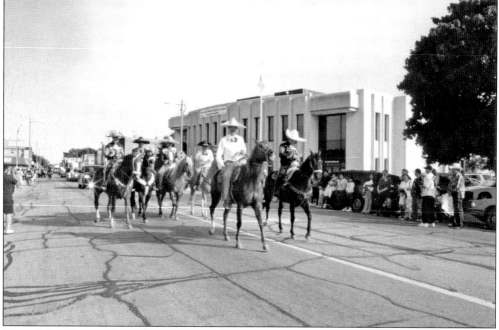

Part of the HispanoFest celebration includes a parade. Pictured here, a group of caballeros on horseback wear traditional Mexican cowboy garb as they ride down Lake Street in front of the old Melrose Park National Bank building.

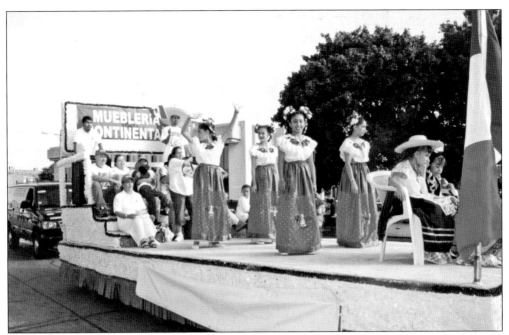

HispanoFest is specifically designed to be a family-oriented event. The festival raises money for scholarships for students of Hispanic origin. Children and families are actively encouraged to participate in the various activities. This float features a group of young Hispanic girls wearing peasant dresses.

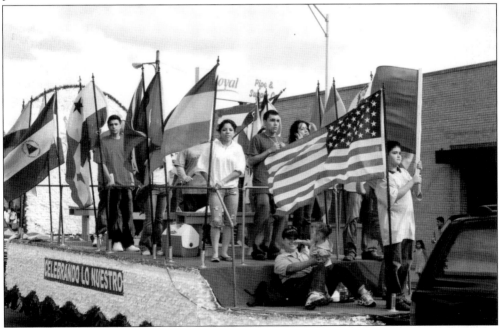

A float bearing the caption "Celebrando Lo Nuestro" travels west on Lake Street toward the celebration. Children proudly accompany the flags of many South, North, and Central American nations including the United States, Mexico, Bolivia, Columbia, Panama, and Nicaragua. These flags represent the diversity of the Hispanic population in Melrose Park.

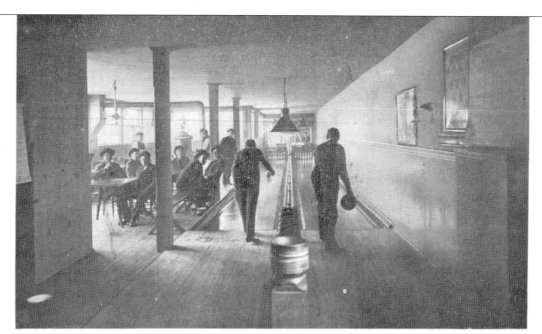

GOLDACKER & SON

BOWLING ALLEYS AND POOL ROOMS

Fifteenth Ave. and First St. TELEPHONE 7871 MELROSE PARK, ILL.

Bowling was a popular recreational sport in early Melrose Park. Located at Fifteenth Avenue and First Street, Goldacker and Son was a combination bowling alley/pool room frequented primarily by gentlemen. This advertisement, taken from the *1907 Village of Melrose Park Souvenir Book*, depicts two bowlers competing side by side in the two-lane bowling alley. Looking closely, a human pinsetter is visible at the end of the right-hand lane.

Six

THE PALM SUNDAY TWISTER

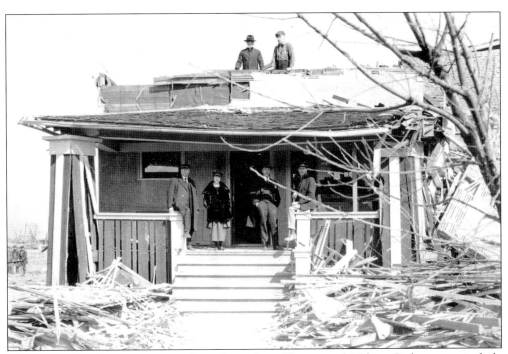

On March 28, 1920, a twister tore through northern Illinois, and Melrose Park was particularly hard hit. Shortly after noon on Palm Sunday, the storm followed a wide path through downtown Melrose Park, proceeding northeast through the village. At least nine villagers lost their lives, 32 homes were totally destroyed, and 62 others were damaged. The home pictured here exemplifies the catastrophic devastation wrought by the storm. A path through the rubble was obviously cleared to allow residents to pose on the porch of their formerly two-story house.

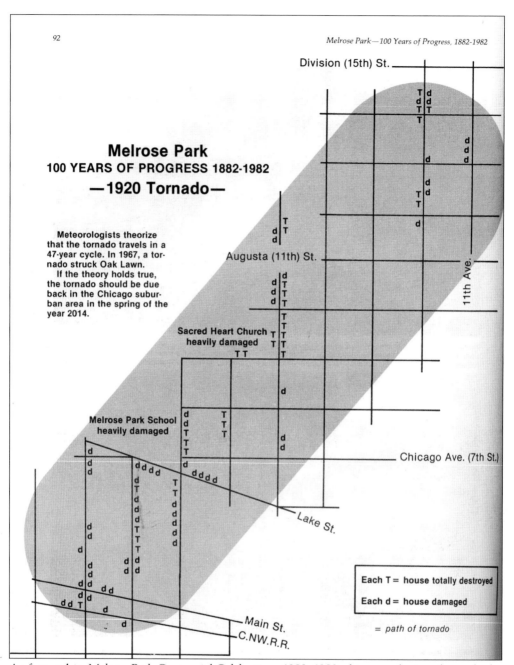

Melrose Park
100 YEARS OF PROGRESS 1882-1982
—1920 Tornado—

Meteorologists theorize that the tornado travels in a 47-year cycle. In 1967, a tornado struck Oak Lawn.
If the theory holds true, the tornado should be due back in the Chicago suburban area in the spring of the year 2014.

Division (15th) St.

Augusta (11th) St.

11th Ave.

Sacred Heart Church heavily damaged

Melrose Park School heavily damaged

Chicago Ave. (7th St.)

Lake St.

Each T = house totally destroyed

Each d = house damaged

= path of tornado

Main St.
C.NW.R.R.

As featured in *Melrose Park Centennial Celebration, 1882–1982*, this map depicts the path the tornado tore through the village. The tornado initially touched down just south of the Chicago and Northwestern Railway tracks in Maywood before moving northeast through Melrose Park.

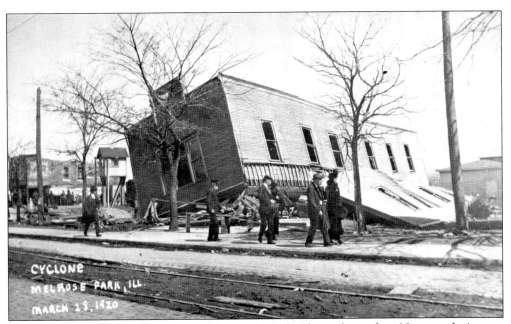

One of the first local residences to be hit was the Balzer home located on Nineteenth Avenue just south of the railroad station on the border of Maywood and Melrose Park. Although the frame house was blown completely off its foundation, the telephone pole directly to the right remained upright.

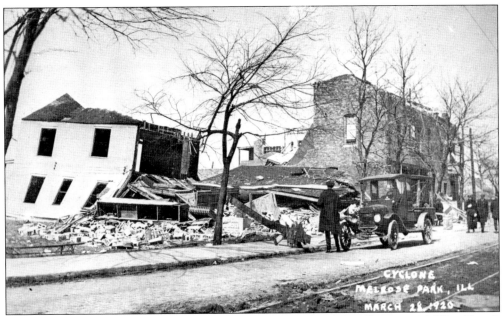

Across the street from the Balzer home on the other side of the Chicago and West Town's Streetcar line, several buildings in Maywood were completely destroyed. Even the sturdier brick structures were not immune to the fierce winds.

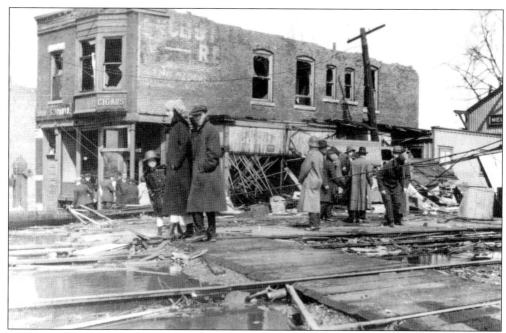

The tornado first touched down in Melrose Park on Nineteenth (Broadway) Avenue where the business district was particularly hard hit. This photograph depicts a commercial building just west of the Chicago and Northwestern Railway station that sustained considerable damage. Pictured in the foreground, a family crossing over the tracks pauses in front of the windowless building.

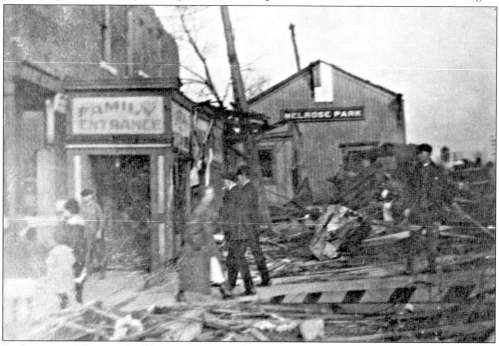

In this view of the same building on Nineteenth Avenue, the wreckage is even more evident. In the foreground, a railroad crossing gate rests amid the rubble. The Melrose Park railroad station in the background appears to be relatively undamaged.

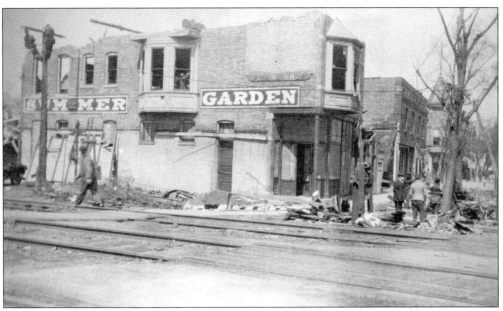

Directly across the street from the previous picture, a building on the west side of Nineteenth Avenue bearing a plaque reading "Pisano Bros." was heavily damaged. Looking closely, one can see a ghostly figure in the second-story window, perhaps beginning the arduous clean-up process.

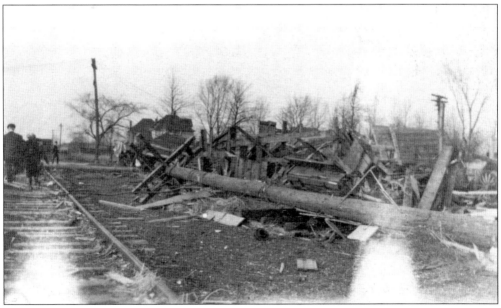

In a scene somewhere along the Chicago and Northwestern Railway tracks, piles of debris litter the area. Identifiable objects scattered among the debris include a wagon, a desk, and a toppled telephone pole.

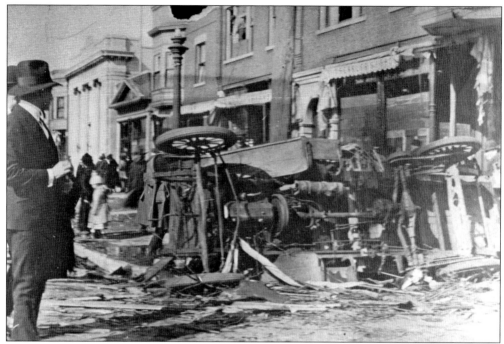

According to the handwritten caption on the back of this photograph, the toppled truck on Nineteenth Avenue and Main Street in front of Trenkler's Grocery and Market belonged to Edward Fiebrandt of Elmhurst. The ill-fated furniture delivery truck had the misfortune of arriving in Melrose Park just as the tornado struck.

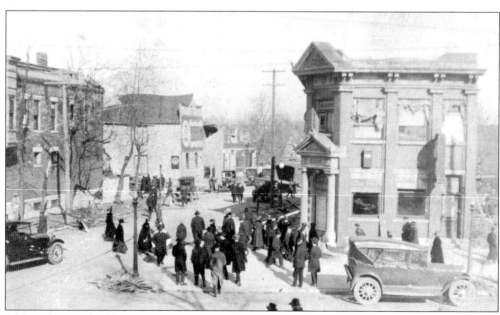

Although many buildings on Nineteenth Avenue were damaged or completely destroyed by the tornado, the Citizen's State Bank remained relatively unscathed. Here residents gather to survey the damage and to begin the clean-up process.

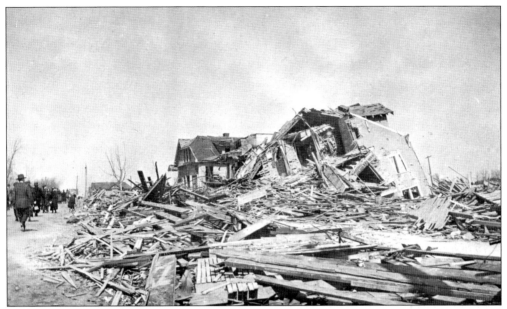

Among the 32 private homes completely destroyed by the Palm Sunday tornado was this structure at Fifteenth Avenue north of Lake Street. The utter devastation drew crowds of gapers who milled about staring at the wreckage of the once-tidy neighborhood.

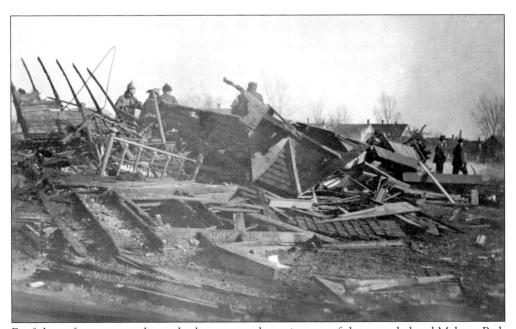

Firefighters from surrounding suburbs came to the assistance of the overwhelmed Melrose Park Fire Department on the day of the tornado. Pictured here on this postcard, a group of firemen poke among the smoldering debris in search of survivors.

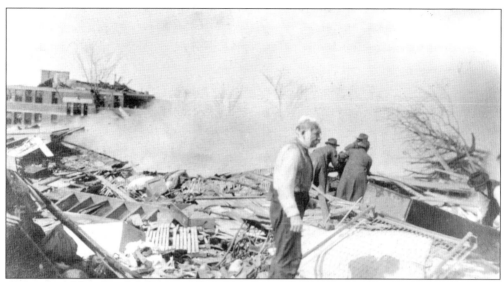

A dazed and bandaged survivor walks amid the smoking ruins of the Steinkebel home on Seventeenth Avenue and Lake Street. The Steinkebel home was not only leveled by the tornado, but the rubble also caught fire and burned. A heavily damaged and windowless Melrose Park School stands in the background.

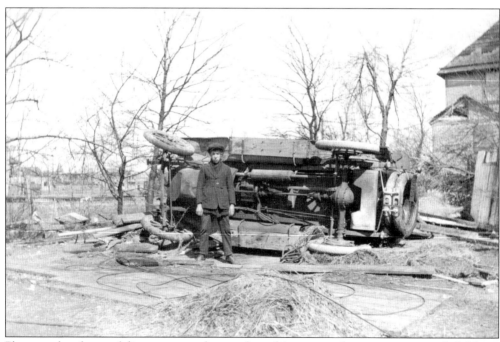

Photographs of natural disasters were often used as subject matter for souvenir postcards. Melrose Park's Palm Sunday twister generated a series of postcards visually depicting the inconceivable extent of the damage. This postcard, featuring a young boy standing in front of an overturned automobile, is one of 20 such postcards in the Melrose Park Historical Society's collection.

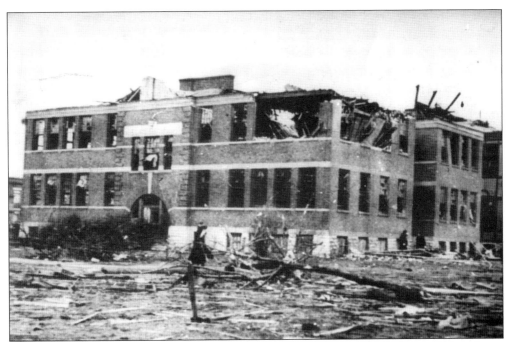

One of the hardest-hit structures was the Melrose Park School at 1715 Lake Street. Although not totally destroyed, every window was blown out, and the roof suffered extensive damage. Imagine the horror if the tornado had struck on a school day.

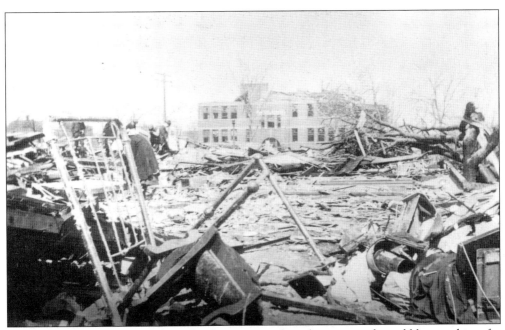

In a more distant view of the school, townspeople poke among the rubble searching for anything salvageable. The buildings directly to the south of the school appear to have been leveled. The destruction was so complete, only the bed frame on the left side of the photograph remains identifiable.

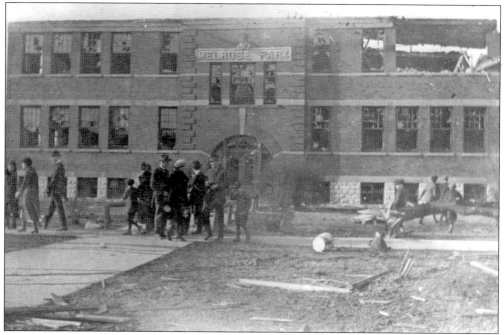

In a scene reminiscent of the aftermath of a wartime bombing, local residents and schoolchildren gather in front of the shattered shell of the Melrose Park School. The tree in the right foreground has been totally uprooted, providing a convenient bench for the children.

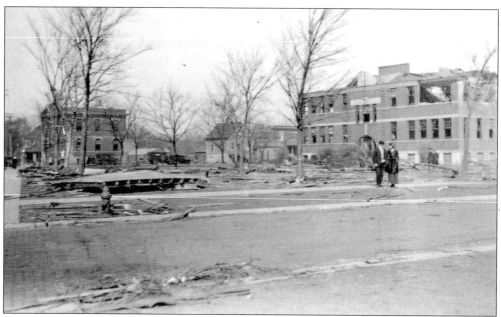

In this photograph, probably taken several days after the tornado, much of the rubble has been cleared away, allowing people to walk unimpeded directly in front of the school. The buildings in the background appear to be relatively unscathed.

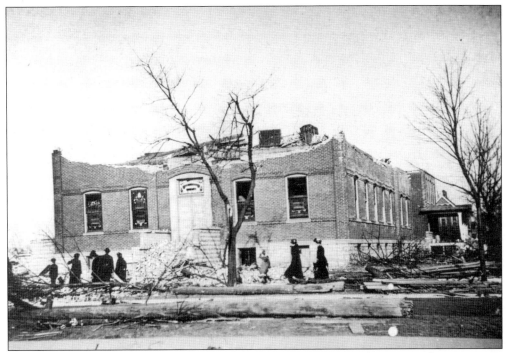

Sacred Heart Church was another unlucky casualty of the 1920 tornado. Because the twister tore through Melrose Park at approximately 12:47 p.m., Palm Sunday services had already concluded. Many trees were uprooted, and the entire second floor of the building was ripped off by the force of the tornado.

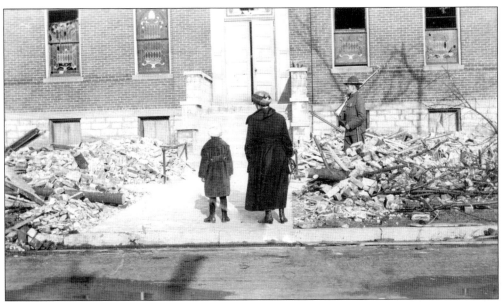

An armed soldier stands guard in front of Sacred Heart Church to prevent looting in the aftermath of the storm. A woman and child survey the ruins of their church. Despite the ferocity of the winds, some of the precious stained-glass windows remained intact.

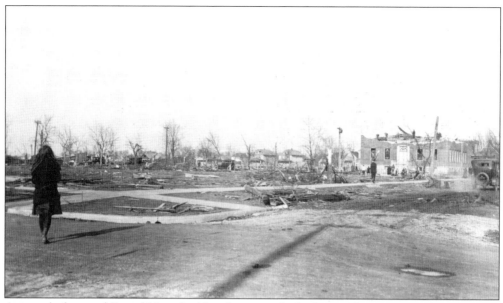

A severely damaged Sacred Heart building looms in the background as a young girl walks down the street at the intersection of Iowa Street and Seventeenth Avenue. In addition to the church, the Sacred Heart building also housed the school and the convent, where three nuns were injured during the tornado.

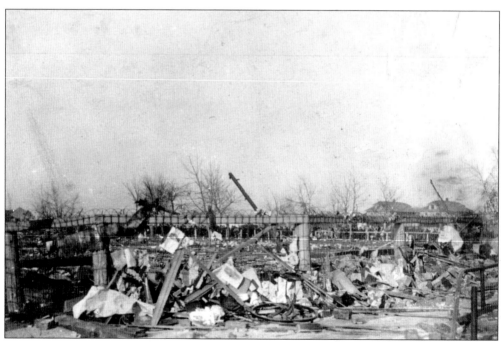

Debris litters the remains of the Sacred Heart schoolyard. The damage to the school was so extensive that classes were canceled for the remainder of the year. According to the *Sacred Heart Church Centennial Book*, "Seventh and eighth grade boys cleaned bricks at ten cents each, credits to be redeemed at the upcoming parish carnival."

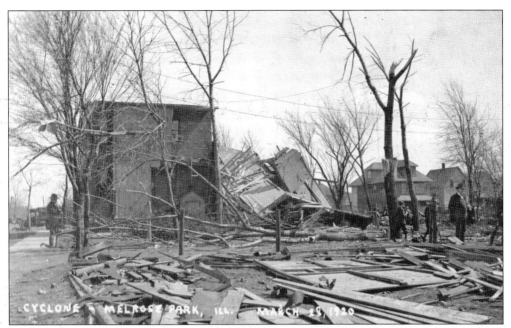

The random path of destruction is revealed in this photograph of the neighborhood at Sixteenth Avenue and Rice Street. According to the American Red Cross publication *Tornado Disaster Relief: 1920*, "Many houses were totally demolished; others suffered all degrees of damage from slight injury to the roofs and broken window panes to actual lifting from foundations and depositing upside down on neighboring lots."

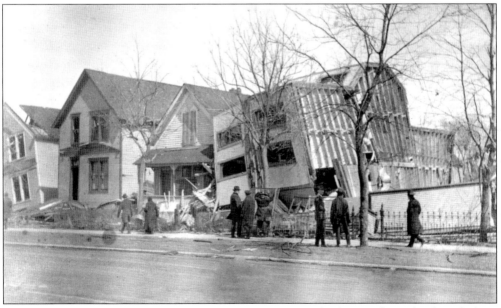

The Claus house at 125 North Eighteenth Avenue was completely tipped over by the gale-force winds. Pictured here, the house rests on its side; the sideways front door is visible at the bottom center of the photograph.

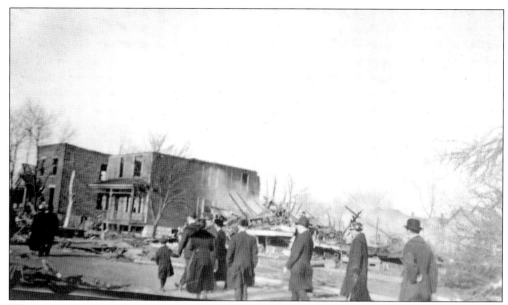

This picture postcard depicts the east side of Seventeenth Avenue just north of Chicago Avenue. Another smoldering ruin of a house sits in the background. Passersby do not seem at all fazed by the all-too-commonplace sight.

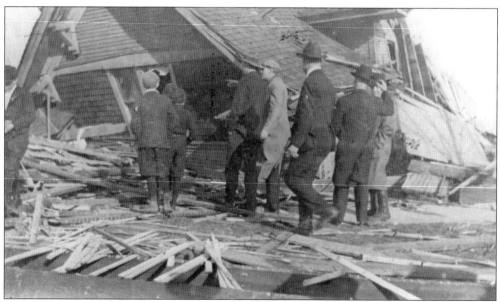

This photograph shows details of the destruction of a home at Sixteenth Avenue and Walton Street. It appears that the house collapsed in on itself, enabling the young boy in the foreground to stand and look into a second-story window.

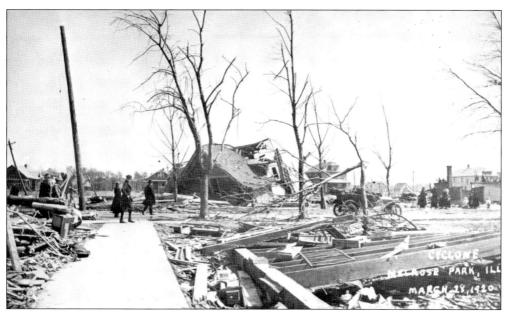

This more distant view of Sixteenth Avenue and Walton Street provides a comprehensive view of the entire neighborhood. Note the scattered homes that remained untouched amid their severely damaged neighbors.

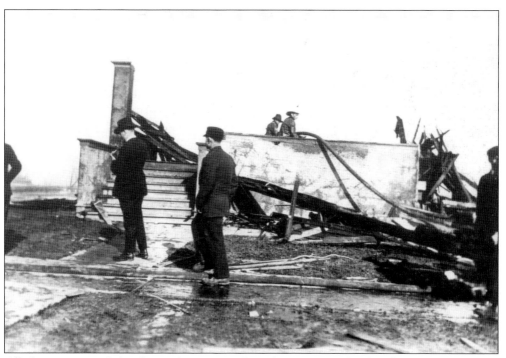

All that remains of this former home on Fifteenth Avenue is the foundation and the front stairway. Firefighters are hosing down the remnants of the home as a safety precaution.

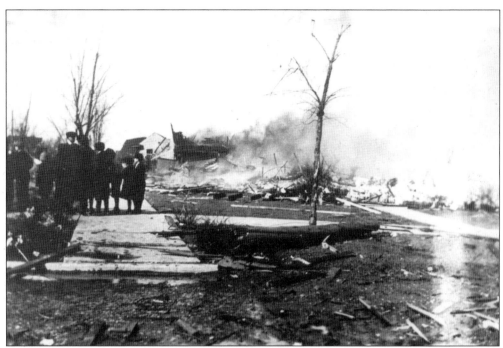

Homes farther north along the tornado's path of destruction were not immune. Here at Fourteenth Avenue north of Augusta Street, a group of onlookers gathers in front of yet another burning home.

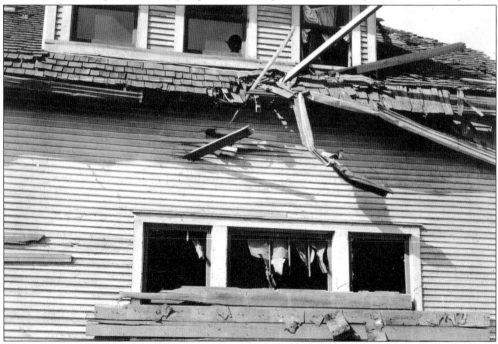

Many houses suffered severe damage from the high-powered winds. This home is a prime example of the type of devastation wreaked by the storm. In addition to windows being blown out and roofs being ripped off, flying debris—like the board impaled in the siding of this home—caused significant damage.

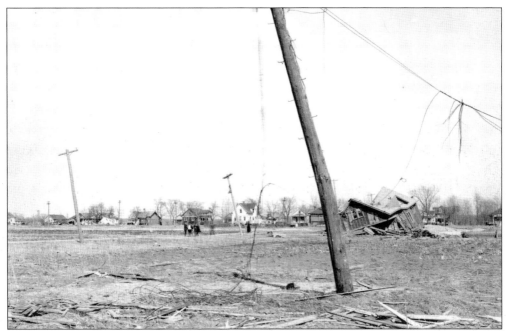

The listing telephone pole in this relatively unpopulated prairie area stands as stark evidence of the damage caused by the tornado. The random path the tornado took is again graphically illustrated by the total destruction of the home in the foreground, while several hundred yards away, other homes appear to be unscathed.

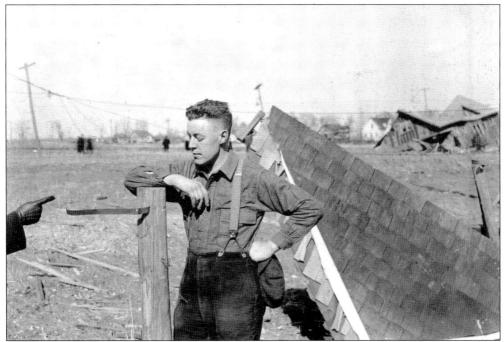

The harsh toll exacted by the twister could be measured in emotional as well as physical terms. In this photograph, a survivor seems to contemplate both the immediate damage and the uncertain future. Note the mysterious gloved hand that seems to be demanding some sort of action be taken.

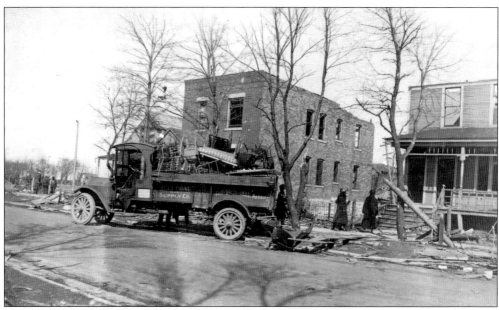

The arduous process of clean up and salvage began almost immediately. Pictured here on the 700 block of Seventeenth Avenue, a Belt Coal and Supply Company truck was enlisted to aid in the cleanup efforts. Many local area businesses volunteered both equipment and manpower to assist the village.

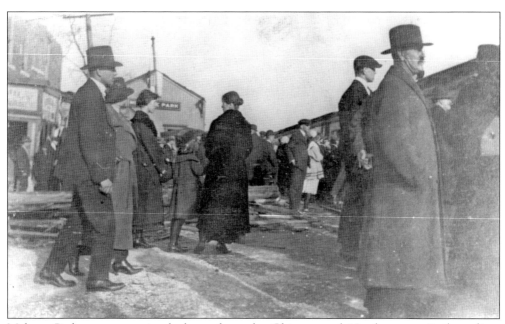

Melrose Park was conveniently located on the Chicago and Northwestern Railway line, making the rapid delivery of relief supplies and manpower possible. Pictured here, a relief train, eagerly awaited by beleaguered Melrose Park residents, arrives at the train station on Nineteenth Avenue.

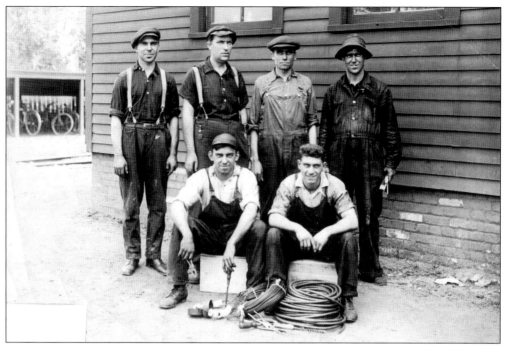

Pictured is a crew of cleanup volunteers from the National Malleable and Steel Castings Company. The handwritten inscription on the back reads, "The IO——N wrecking gang who have been working off their surplus energy as reconstruction wire men in Melrose Park cyclone district. As volunteers in this work they have upheld the credit of the National Malleable Castings Company."

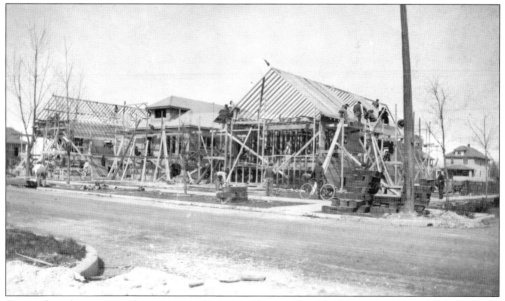

Soon after the catastrophe, construction crews began the rebuilding process in Melrose Park. According to the Red Cross report, "Men from the following unions volunteered: Carpenter's, Masons', Bricklayers', and Switchmen's. These men gave their vacation time, Saturday afternoons and Sundays, which meant much sacrifice on their part."

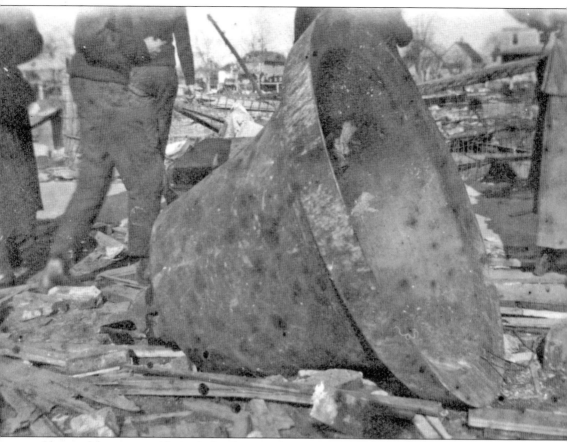

In one of the most starkly symbolic photographic images captured in the aftermath of the Palm Sunday twister, the intact cast-iron bell of the Sacred Heart Church lays on its side amid the rubble near Sixteenth Avenue and Iowa Street. It is a tribute to the faith and perseverance of the citizens of Melrose Park after the initial shock had worn off; they immediately began rebuilding their ravaged community.

Seven

THEN AND NOW

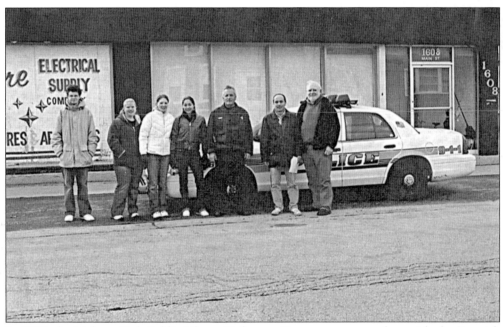

In 2007, the Melrose Park Public Library Reference Department teamed up with the Fenwick High School Photography Club to replicate a series of photographs originally appearing in the *1907 Village of Melrose Park Souvenir Book*. The resulting then and now exhibit serves as the basis for the majority of this chapter. Pictured from left to right are Christopher Wojewoda, Joellyn Schefke, Bridget Kern, Araceli Diaz, Daryl Farmer, Fidencio Marbella, and Ron Stuart.

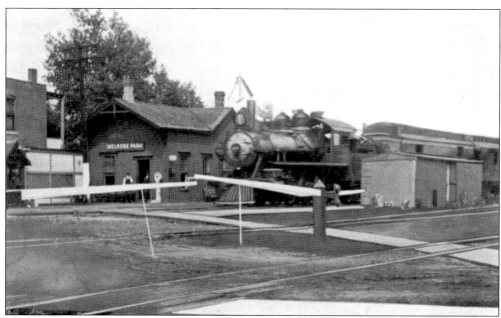

Melrose Park had its origins as a stop on the Chicago and Northwestern Railway. Pictured here is the Melrose Park stop on Broadway Avenue in 1907 and 2007. In the 1907 scene, a steam locomotive with old-style passenger cars pulls into the vintage depot located just north of the tracks. The small shack to the left sheltered the crossing guard responsible for manually lowering and raising the crossing gates. The scene below depicts a modern Metra locomotive with stainless steel passenger cars heading east toward Chicago. This classic depot was eventually demolished and replaced with a simple shelter.

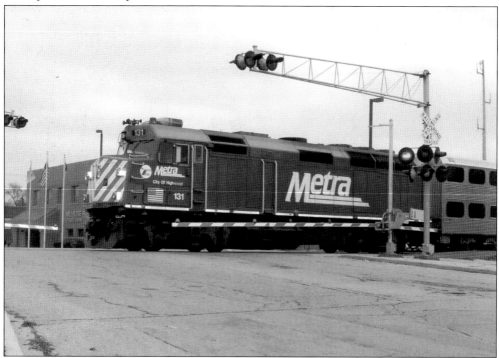

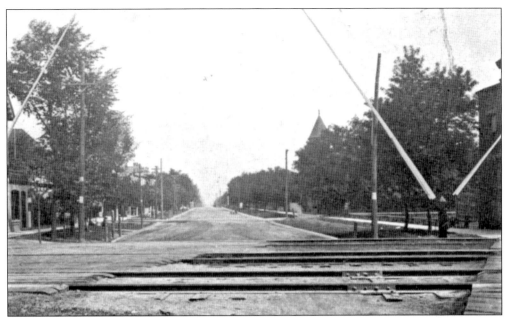

In another view of the same railroad crossing on Broadway Avenue, the only visible similarity between the 1907 and 2007 scenes is the existence of crossing gates. Although the area is still a thriving business district in Melrose Park, in 1907, many of the businesses were hidden by trees. Pictured directly north of the tracks in the 2007 photograph is the new Melrose Park Police Department, which was built on the former site of the Melrose Park National Bank in the early 1990s. Of historical note is the fact that the railroad tracks are higher in 2007 than in 1907 because this line was elevated through Chicago, Oak Park, and River Forest in 1915 to eliminate grade crossings. Although the elevation did not extend through Melrose Park, the tracks needed to be slightly raised to ease the slope between the villages.

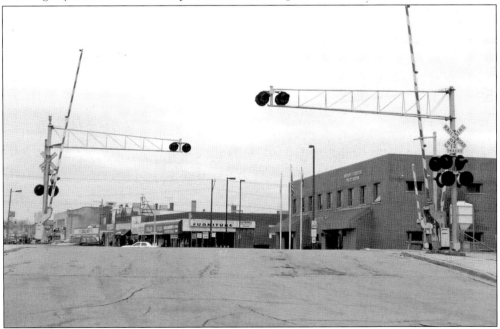

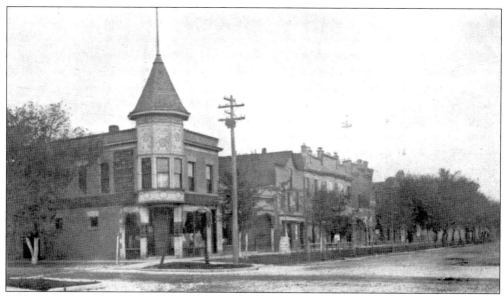

The northwest corner of Main Street and Broadway Avenue was and still is at the south end of the Melrose Park business district. Many of the basic structures remain the same, especially the corner building, constructed in 1902, which still retains its original and easily identifiable cupola. In addition to a storefront, this structure also housed a two-lane bowling alley. The major differences between then and now seem to be the paved streets, the lack of trees, and the altered storefronts.

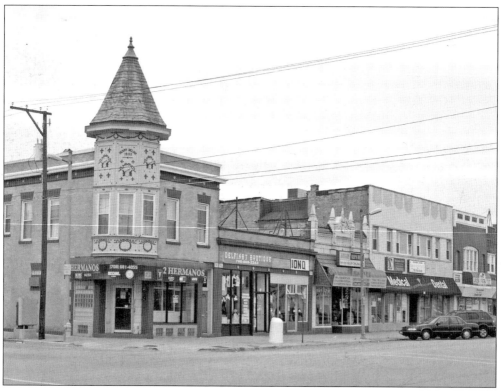

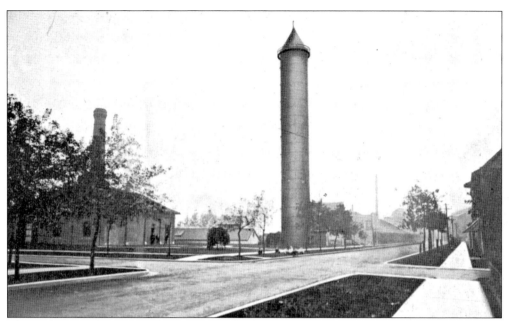

The Melrose Park Waterworks at Twenty-third Avenue and First (Main) Street is pictured in 1907 and 2007. The old water tower was 110 feet high, probably one of the tallest structures in Melrose Park at the time. The pumping station supplied the town with fresh water in the days before Lake Michigan water was piped into the area. The well went down 1,800 feet, and the water was drawn by an air compressor. The new pumping station, located on the far left of the picture below, was built in 1913 and still operates today.

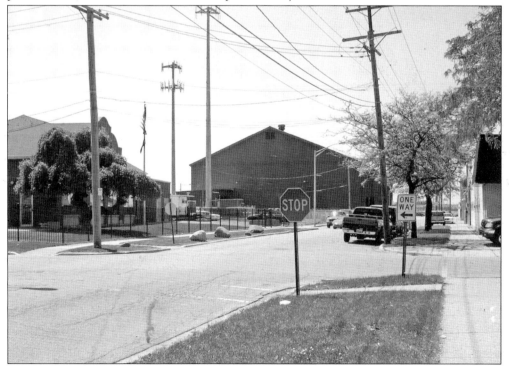

The corner of Nineteenth (Broadway) Avenue and Lake Street has changed radically over the past 100 years. By 2007, all the residences along the once-shady Lake Street were replaced by businesses and an expanded Melrose Park School. For some reason, the telephone pole pictured in the 1907 photograph is clearly located on the street rather than the parkway. The one obvious similarity between then and now is the fact that a fence is located on the southeast corner of the intersection—a wooden fence in 1907 and a wrought iron one in 2007.

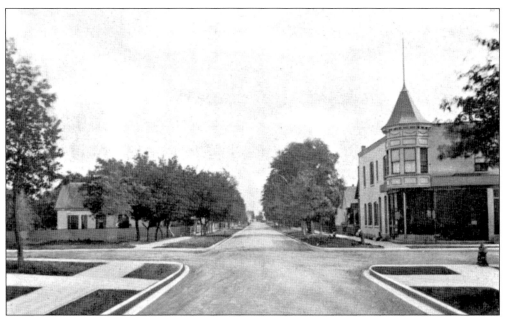

The original building depicted on the southwest corner of Twenty-first Avenue and Lake Street remains standing today. Although the spire is gone and awnings have been added to the second story, the decorative scrollwork remains basically the same 100 years later. The small cottage tucked away behind the trees on the opposite side of the street has been replaced by a commercial establishment.

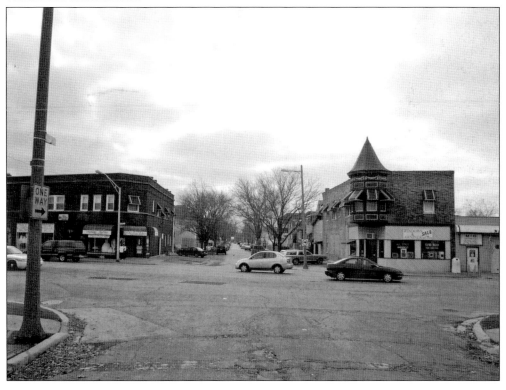

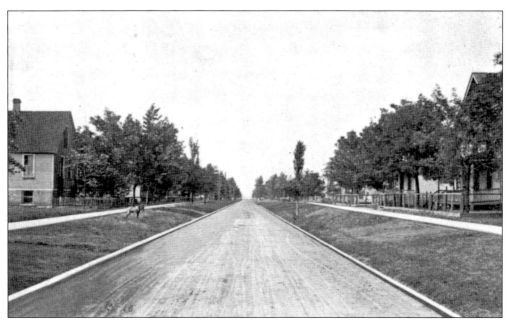

Looking north from the intersection of Twenty-first Avenue and Lake Street, one is struck by the total transformation of this scene. A small pony can be seen on the west side of this quiet residential street in the 1907 photograph. In the 2007 photograph, even though some of the original homes remain, cars have replaced the pony, and businesses stand on both corners of the now-busy street.

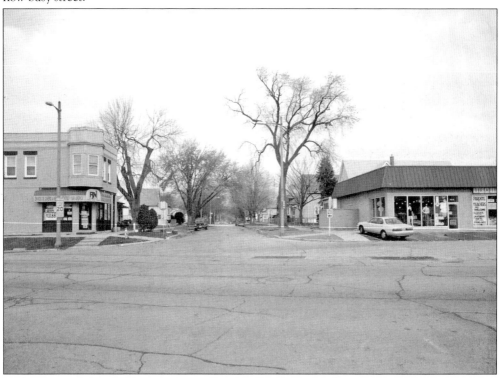

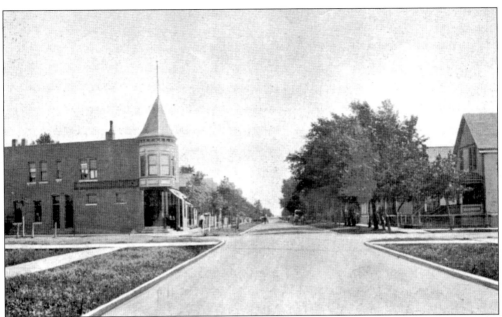

Turrets and cupolas were popular architectural elements of corner buildings at the dawn of the 20th century. Another commercial building, this one on the southeast corner of Lake Street and Twenty-third Avenue featuring a turret and an ornate cupola, is pictured here. In the 1907 photograph, two horse-drawn vehicles are evident on both sides of the street. By 2007, the building had lost its distinctive cupola, but the now-sided turret remains. The original house still stands on the southwest corner.

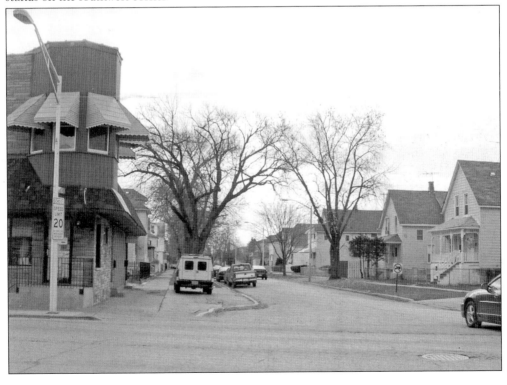

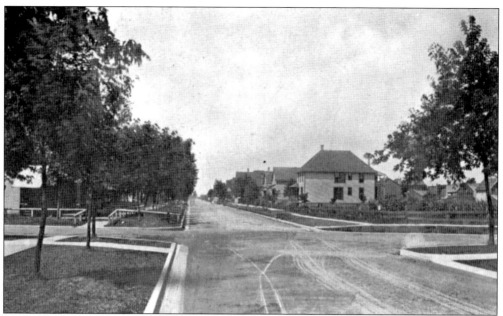

In 1907, a group of recently constructed houses and newly planted trees lined Twenty-third Avenue. Looking north from First (Main) Street, it appears rows of crops have been planted on the large corner lot. Today the area is no longer strictly residential, as commercial buildings have replaced some of the houses.

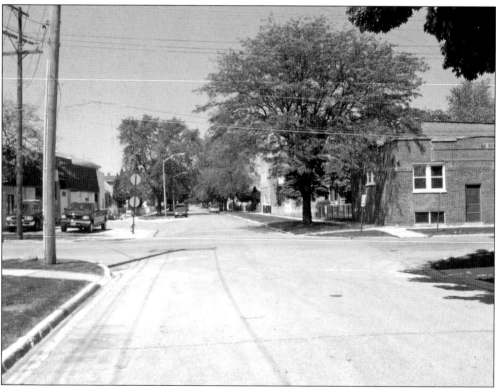

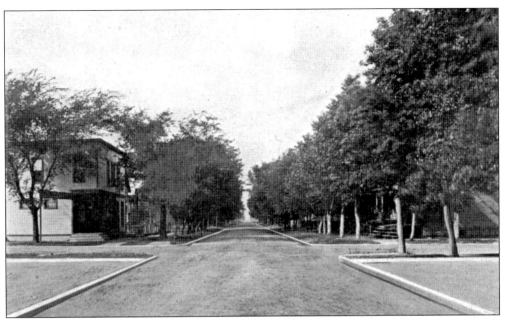

The contrast between the 1907 and 2007 photographs of Twentieth Avenue looking north from Main (First) Street is readily apparent. The street has been widened, and a number of trees have been removed to make way for the commercial structures and apartment buildings that stand at the intersection.

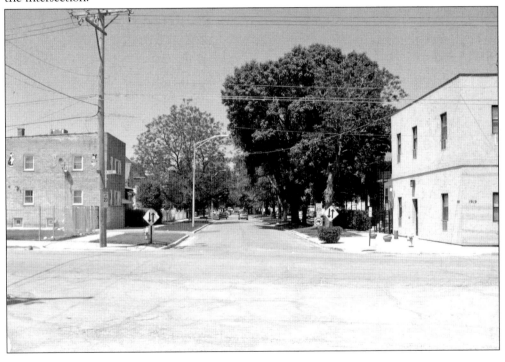

Looking north on Seventeenth Avenue from First (Main) Street, local florist N. P. Larson's greenhouse roof is barely visible behind the stand of shade trees on the east side (right) of the street. Single-family homes line the west side of the street. In the contemporary view of this location, Larson's greenhouse and spacious land tract at 113 Seventeenth Avenue have been replaced by apartment buildings constructed to accommodate Melrose Park's growing population.

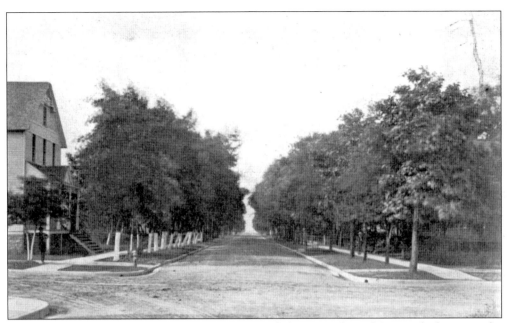

In these two views of Fifteenth Avenue looking north from First (Main) Street, the house on the west side of the street looks remarkably the same despite the passage of 100 years time. In 1907, the trees in this relatively new residential neighborhood appear to be recently planted.

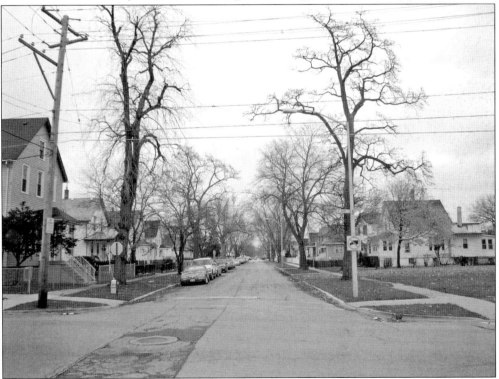

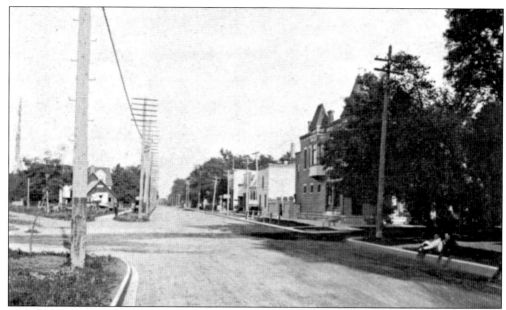

While still retaining its commercial character, Lake Street east of Fifteenth Avenue has changed significantly in the intervening 100 years. Westlake Hospital, opened in the 1920s, appears in the background of the 2007 view, while in the 1907 photograph, the north side of the street was not yet fully developed. In the foreground of the 1907 photograph, two residents lounge on the corner, posing for the photographer.

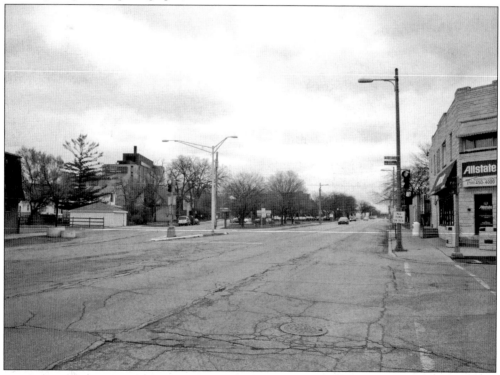

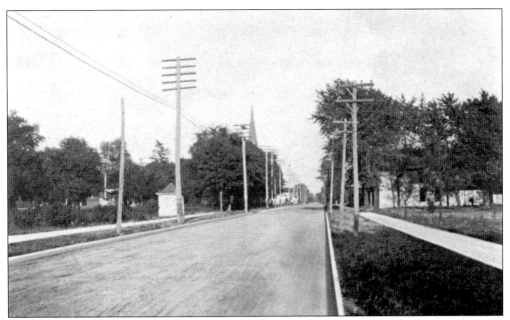

In the 1907 photograph, farther along on Lake Street looking east from Thirteenth Avenue, the steeple of St. Paul's Lutheran Church looms in the background of the less-developed neighborhood. Since old St. Paul's was replaced by a new church building in 1958, this steeple no longer exists. In the 2007 photograph, an ever-expanding Westlake Hospital has acquired land on both sides of the street.

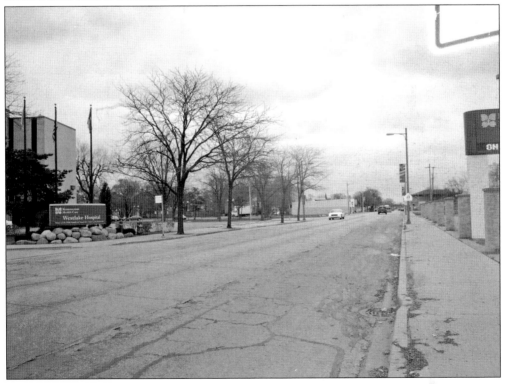

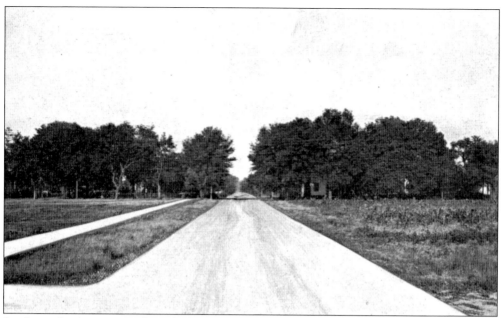

In these close-up views of Sixth (Superior) Street looking east from Twelfth Avenue, the contrast between then and now is stark. In 1907, the street appears to be lined by farm fields with crops clearly visible on the south side of the street. In 2007, Westlake Hospital dominates the scene, and the street dead-ends on the border between the hospital and Walther Lutheran High School.

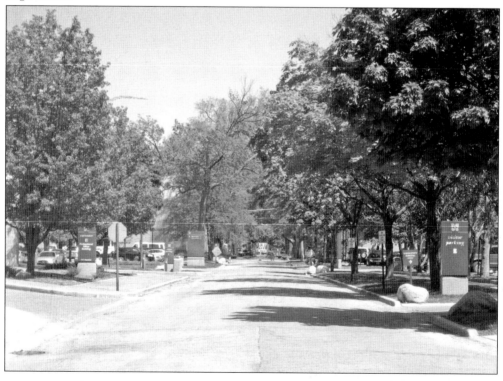

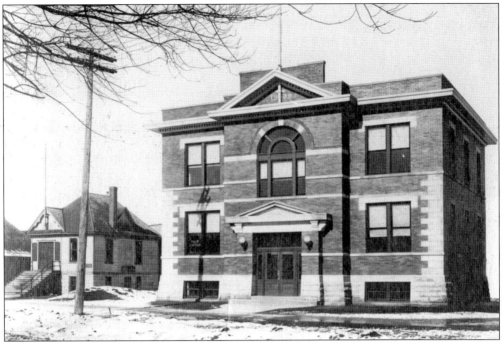

In 1908, the newly constructed brick Melrose Park Municipal Building, located on Lake Street and Eighteenth Avenue, sits directly beside the old wooden village hall. The new municipal building housed the mayor's office, the courthouse, and the police station. In the 1980s, the town's municipal offices were all moved to the new Melrose Park Civic Center complex at 1000 North Twenty-fifth Avenue. The civic center campus now includes village government offices, a senior citizens' complex, public works facilities, a state-of-the-art soccer/football field, and a basketball court.

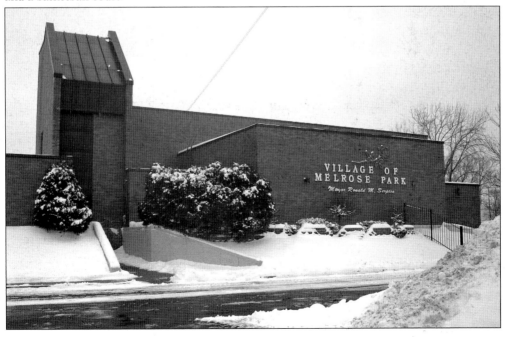

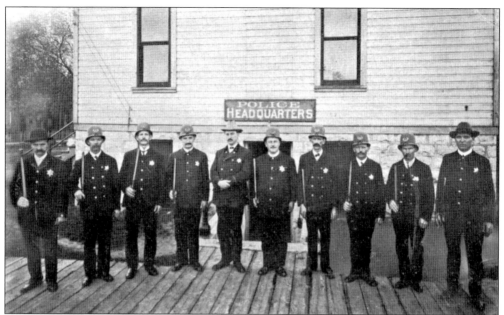

In 1907, members of the Melrose Park Police Department pose in front of police headquarters on Lake Street. Pictured from left to right are Henry Decker, James Lavin, George Matters, Julius Karus, Christ Neumann, Peter Roggenbuck, Aug. Schuette, C. W. Evans, Tony Prabisch, and Henry Pein. In 2007, a more diverse group of police department employees poses in front of the new station on Broadway Avenue. Pictured from left to right are Steve Pesce, Bernardo Guillen, Gene Cacciatore, Nunzio Maeillo, Jesus Tejada, Adam Gibson, Angela Williams, Chane Fogg, Eddie Guzman, and Michael Castellan.

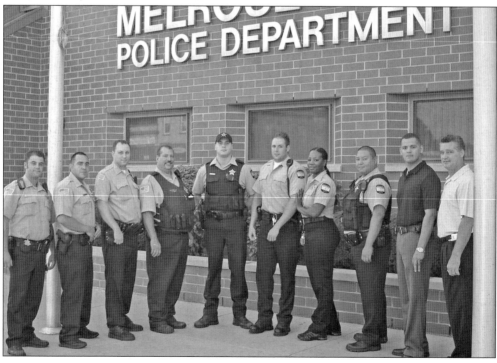

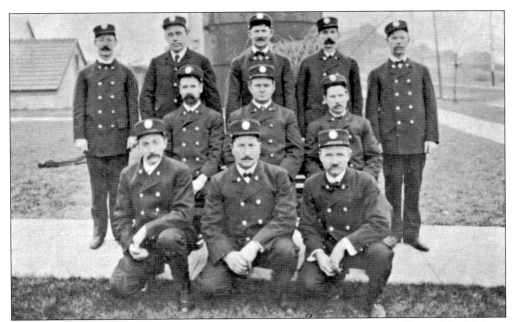

In 1907, members of the Melrose Park Volunteer Fire Department posing in front of the Melrose Park Waterworks Tower included G. W. Buchholz, William G. Korrell, Frank Steinke, Fred Werobke, James Lavin, C. H. Fritche, Herman Jedike, A. Schuette, George Kopp, Herman Puttkammer, and L. W. Richter. In 2007, a group of firefighters stands in front of a Melrose Park fire truck. Pictured from left to right are Jason Wrosch, Rex Putra, John Simon, Dio Vacarro, Sebastian Lorenzo, Ralph Caliendo, Rick Beletrane, Ron Biscan, Jim Karabatsos, and Steve Morella.

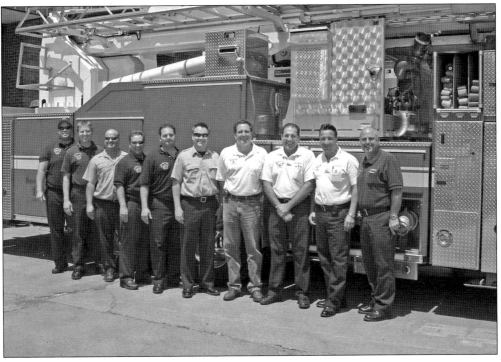

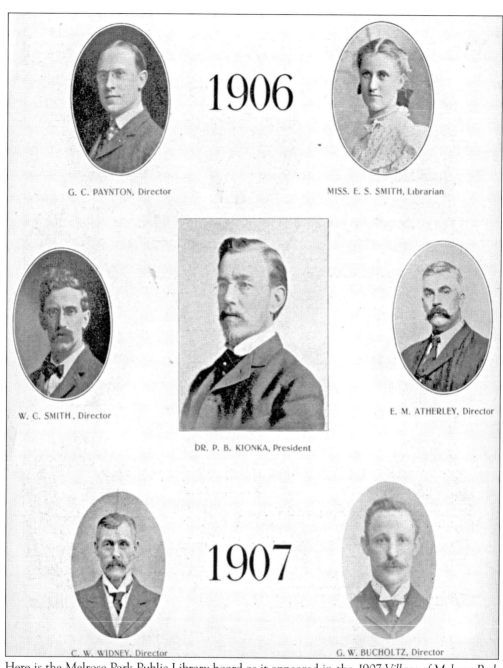

1906

G. C. PAYNTON, Director

MISS. E. S. SMITH, Librarian

W. C. SMITH, Director

DR. P. B. KIONKA, President

E. M. ATHERLEY, Director

1907

C. W. WIDNEY, Director

G. W. BUCHOLTZ, Director

Here is the Melrose Park Public Library board as it appeared in the *1907 Village of Melrose Park Souvenir Book*. Board members pictured include G. C. Paynton, librarian E. S. Smith, W. C. Smith, president Dr. P. B. Kionka, E. M. Atherley, C. W. Widney, and G. W. Buckholtz.

Melrose Park Public Library Board

Teri Cervone,
Treasurer

John Misasi

Barb Giordano,
Library Director

John Culotta

Veronica Bonilla-Lopez

Loretta Gustello, President

2007-2008

Carl Alaimo

Henry Latzke

Pictured here are the 2007–2008 Melrose Park Public Library board members, including Teri Cervone, John Misasi, library director Barbara Giordano, John Culotta, president Loretta Gustello, Veronica Bonilla-Lopez, Carl Alaimo, and Henry Latzke.

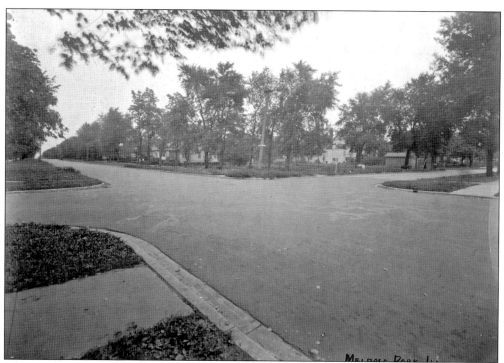

Pictured here on September 26, 1934, is the intersection of Broadway Avenue and Rice Street. The vacant lot on the northeast corner of the street became the site of the Melrose Park Post Office, built in 1935. In 1971, this post office was converted into the Melrose Park Public Library.

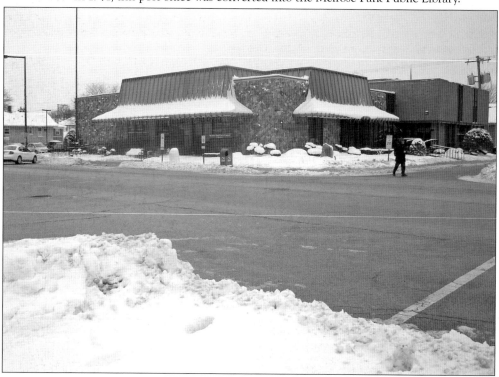

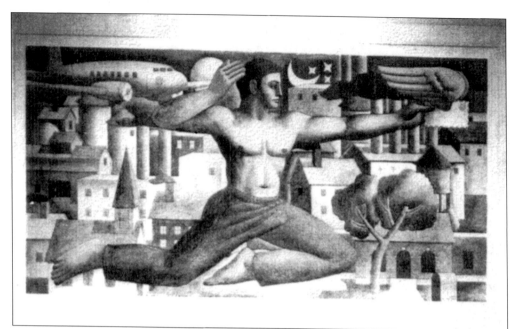

In 2007, librarians discovered the remnants of a New Deal–era fresco hidden above a drop ceiling in the renovated Melrose Park Public Library. *Airmail* was painted by Edwin Boyd Johnson in 1937 under the auspices of the treasury section of fine arts. During the renovation process, the fresco was severely damaged when making room for the installation of ductwork. According to Johnson, "The theme for the mural is a simple one . . . the figure is symbolical representing the spirit of the airmail . . . the background is a composite picture of buildings and houses typical of the village in Melrose Park." Pictured here are then and now photographs of both the undamaged fresco and the pieces that remain intact. Library staff members are attempting to raise funds to fully restore this piece of local history.

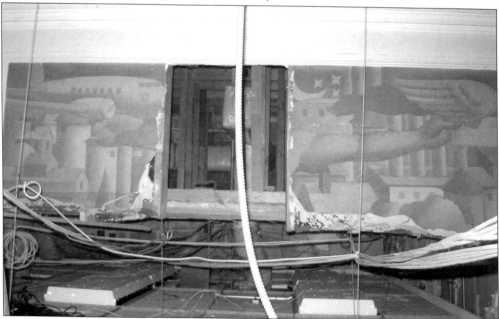

ACROSS AMERICA, PEOPLE ARE DISCOVERING SOMETHING WONDERFUL. THEIR HERITAGE.

Arcadia Publishing is the leading local history publisher in the United States. With more than 3,000 titles in print and hundreds of new titles released every year, Arcadia has extensive specialized experience chronicling the history of communities and celebrating America's hidden stories, bringing to life the people, places, and events from the past. To discover the history of other communities across the nation, please visit:

www.arcadiapublishing.com

Customized search tools allow you to find regional history books about the town where you grew up, the cities where your friends and family live, the town where your parents met, or even that retirement spot you've been dreaming about.